From Mother Goose to Dr. Seuss

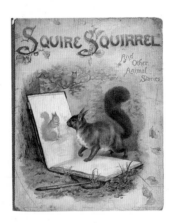

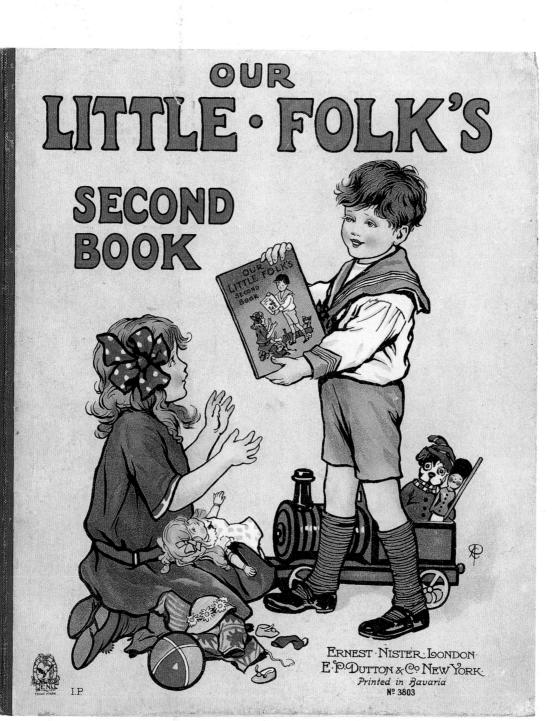

OUR
LITTLE · FOLK'S
SECOND BOOK

OUR
LITTLE FOLKS
SECOND
BOOK

ERNEST · NISTER · LONDON ·
E · P · DUTTON & C? NEW YORK ·
Printed in Bavaria
N? 3803

E.N.
TRADE MARK

I.P.

From Mother Goose to Dr. Seuss

Children's Book Covers 1860–1960

BY HAROLD DARLING

FOREWORD BY SEYMOUR CHWAST

CHRONICLE BOOKS
SAN FRANCISCO

Library of Congress Cataloging-in-Publication Data:

Darling, Harold.

 From Mother Goose to Dr. Seuss: children's book covers 1860–1960 / by Harold Darling.

 p. cm.

 Includes index.

 ISBN 0-8118-1898-5

 1. Bookbinding—Great Britain—History—19th century. 2. Bookbinding—United States—History—19th century. 3. Bookbinding—Great Britain—History—20th century. 4. Bookbinding—United States—History—20th century. 5. Children's Books—Great Britain—History—19th century. 6. Children's Books—United States—History—19th century. 7. Children's Books—Great Britain—History—20th century. 8. Children's Books—United States—History—20th century. I. Title. II. Title: From Mother Goose to Dr. Seuss.

Z270.G7D37 1999

686.3'0941—dc21
 98-48960

 CIP

Printed in Hong Kong.

Cover and book design by Lian C. Ng

1 **Squire Squirrel and Other Animal Stories** *Ernest Nister, London. 1895*
2 **Our Little Folk's Second Book** *Ernest Nister, London. 1910s.*
 Illustration: Rosa C. Petherick
4 **ABC-Buch** *Georg Wigand's Verlag, Leipzig. 1845. Illustration: Ludwig Richter*

Distributed in Canada by Raincoast Books
8680 Cambie Street
Vancouver, British Columbia V6P 6M9

10 9 8 7 6 5 4 3 2 1

Chronicle Books
85 Second Street
San Francisco, California 94105

www.chroniclebooks.com

Table of Contents

Foreword

by Seymour Chwast

Book design always reflects the aesthetics, ethics, and technologies of the periods in which the books are produced. Nineteenth-century lithography, for instance, freed artists from the restraints of metal and wood letterpress printing, allowing for embellished lettering, patterns, and borders alongside rendered illustrations. The look of the Victorian era, while perhaps artistically quaint today, represented mechanical advances that allowed the style to flourish.

With the dawn of the twentieth century, social mores, art movements, and production techniques evolved further. Fussy, elaborate lettering yielded to modern type. Commercial artists were free to expand graphic ideas and manipulate images, increasingly using the book jacket as a sales tool versus a mere utilitarian protective sleeve. And children were no longer perceived as "small adults," but were allowed to be childish. Children's books themselves could now be entertaining as well as enlightening.

Designing and illustrating books for children has allowed me the creative play often inappropriate in other areas of my design and illustration work. Many of Harold Darling's wonderful selections herein reflect the kind of innovation that has inspired me. For example, the book the child holds on the frontispiece is a repeat of the cover itself, presumably repeated into infinity. Type becomes a tangible object in *Alphabet Book ABC* (page 84). Certain books take on other concrete qualities: as a painter's palette in *Father Tuck's Merry Times Painting Book* (page 63), a front page newspaper in *Eloise in Moscow* (page 114), and a shipping crate in *From Toy-land* (page 138). *The Slant Book* (page 143) defies formal convention while still obeying gravity, and a mirror becomes a monocle worn by a child on the cover of *Looking-Glass Annual* (page 153).

These children's books—and all carefully crafted books in general—create wonder, spark the imagination, and ultimately satisfy the curiosity of people young and old in order to better enjoy and prepare them for life.

7 **The Road to Storyland** *M. A. Donohue & Co., Chicago. 1934. Illustration: Herbert Rudeen*

8A 8B
8C 8D

8A **Mary's Message, A True Story** 8B **Wm. Hunter, the Young Martyr** 8C **The Power of Love** 8D **The Royal George; or, Too proud to take Advice**
Charles Caswell, Birmingham. 1855

Preface

This work is like a map to a huge and largely unexplored continent. I have collected illustrated children's books for more than thirty years, and yet a week does not go by that I do not discover a remarkable book that I have never before seen or even heard about.

Like all explorers, I feel compelled to make sense of this appalling vastness, and this book is such an attempt. A single volume on a hundred years of children's illustration would tend to concentrate on the major trends and best-known artists. There are such volumes, and they are useful, but this is not such a work. This book is intended to invoke the size, richness, and individuality of the realm of children's books.

The covers in this study are all from books published in Britain and the United States. This is because my interests, my knowledge, the books I had access to, and, I believe, most readers' curiosity, is centered on books published in English.

Whatever the complex of motives that makes children's book covers what they are, I am grateful for the visual bounty, and glad of this opportunity to share my enthusiasms.

10 **Poems by the Rev. George Crabbe** *Printed for J. Hatchard. 1809*

Introduction

Book jackets have evolved from nonexistent to functional wrapping to the panorama of colors, textures, shapes, and attitudes found in any bookstore today. Joyce Irene Whalley and Tessa Rose Chester point out in *A History of Children's Book Illustration* (1988): "Early books were rarely issued ready bound, and certainly there was no case binding such as we know today. Most printed books went to the bookseller in an unbound state, in sheets, or at least with only a temporary cover. They were then bound to the requirements of each purchaser."

Then during the nineteenth century, as Ruari McLean says in *Victorian Publishers' Book-Bindings* (1973), "The old methods of printing and publishing books, virtually unchanged since the invention of printing in the fifteenth century, changed radically: the modern world of mass production was being born." Binding was a great part of that change, for books were now issued with covers, and commercial factors played upon their appearance. Publishers wished their books to sell, and they gradually

came to realize that information on the cover assisted this, and that information attractively conveyed was best. The 1809 book *Poems by the Rev. George Crabbe* (see page 10) is a fair sample of a binding that informs but does not yet appeal. Book covers, which at first existed to protect pages and keep them in order, embarked on a complicated journey.

Charles Rosner, in his article "The Book Jacket: First Principles" (*The Penrose Annual*, 1952), describes a book jacket as "a poster wrapped around a commodity." This is a good description of a cover design in general; however, the children's book cover has a few unique qualities worth mentioning. The creator of this "poster" for children's books is more often than not the illustrator of the book, and not infrequently the author as well. It would be rare in a work of adult fiction that the author would illustrate the cover, whereas in children's books it is common, and, to varying degrees, the illustrator/author also acts as designer and typographer. This would seem to offer the children's book cover illustrator an advantage in their goal to evoke and sell the contents of the book. Not only is the author as illustrator, or the collaborative illustrator, more intimately acquainted with the contents of the book than an outside illustrator (who in the case of adult fiction may or may not have even read the work), but their cover illustration provides a sample of what can be found inside. If one likes the illustration on the cover of a children's picture book, one will most surely like at least half of what is inside! This is obviously not the case with most adult fiction.

A children's book usually must appeal to two buyers, the parent and the child, who sometimes have different agendas. In *A History of Children's Book Illustration* (1988), historians Whalley and Chester aptly sum up this idea: "Though the child may cry for it, it is the parents who will buy it."

The parent is concerned that the book be appropriate for both content and age group. The illustration chosen and the typography used on the cover should begin to answer these questions. Parents must ask themselves if the book will last—will it survive their child? Whalley and Chester offer proof that this concern was present in the nineteenth century as well: "It is interesting to note that these coloured toy books cost one shilling each (5p) unless 'mounted on linen', in which case they cost twice as much. For a popular title that was likely to receive much handling in the nursery, linen mounting was probably an economical proposition." Thus a children's book cover must look sturdy, and the materials chosen to make up the cover and/or jacket must at least convey a sense of strength. The materials used may also constrain and define the nature of the cover and contents; a cloth book (see *The Doggie's Promenade*, page 56) is one example of the need for strong materials helping to define the nature of the book and its cover.

Ultimately, however, the child must ask for the book. What prompts a child to select one cover from among those displayed at a bookshop? We can see that children's picture books look different than books made for young adults, we know that people have tried to appeal to the young mind, and certainly much has been written about what motivates them. However, the honest answer would have to be that we do not know what attracts a child to a book cover, which is perhaps what makes for such an interesting array of attempts.

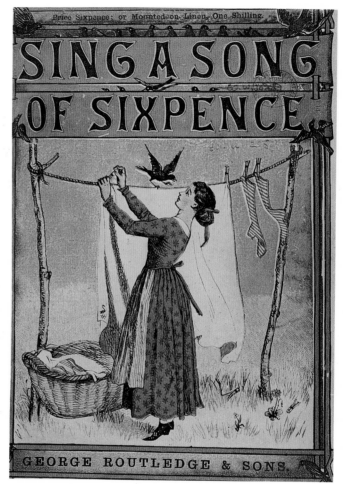

The 1860s

Books specifically for children began to be published in the eighteenth century, and a study of children's literature properly begins there. However, a study of their covers need not pay much attention until the 1860s, because, for a variety of reasons, some of which are discussed in the introduction, their bindings were either simply informational or generically decorative.

Books from the early 1860s usually bear embossed designs. These are sometimes very complex and beautiful, and they arose naturally from the hand tooling on leather-bound adult books, a tradition that developed over hundreds of years. In *A History of Children's Book Illustration* (1988), Whalley and Chester summarize the growth of children's publishing in this era: "The population had expanded considerably during the first decades of Victoria's reign, and more children survived to adulthood as a result of generally improving living conditions. The industrial revolution continued to bring great prosperity to at least some classes of society, and the constant improvement of industrial products and techniques all made for similar betterment in book manufacture and even design, which could now be more adequately carried out by mechanical means than had previously been possible. It was a combination of all these circumstances which led to the flowering of illustration and to the production of some of the most outstanding children's books ever published in England."

The insides of the books showed the same sort of changes during the 1860s. Full-color illustration was frequently used, whereas it had formerly been used rarely, as it involved expensive methods such as stenciling or hand tinting.

14 **Sing a Song of Sixpence** *George Routledge & Sons, London. 1866. Illustration: Walter Crane; Design: Edmund Evans* This book was printed from wood blocks by the great Victorian printer Edmund Evans (1826–1905).

16A 16B

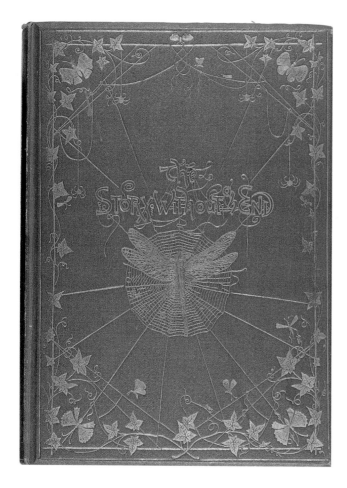

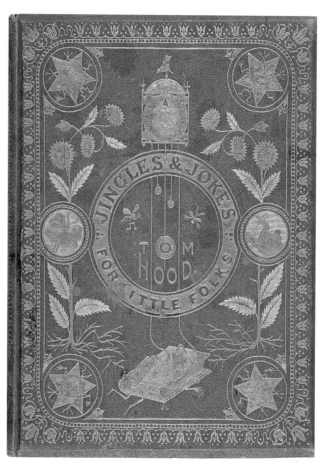

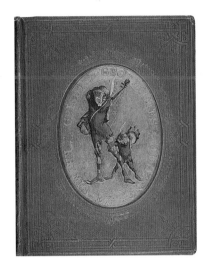 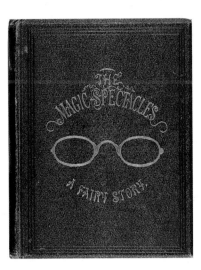 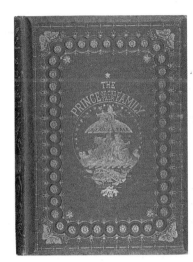

17A 17B 17C

16A **The Story Without an End** *Sampson Low, Son, and Marston, London. 1868. Illustration: E.V.B. (Eleanor Vere Boyle)* The invention of the Arming press in 1832 allowed for the impression of gilt designs (and, later, other colors as well) upon the cover, spine, and back of books. Generally, the cover received most of the book designer's attention. 16B **Jingles & Jokes for Little Folks** *Cassell, Petter & Galpin, London. 1865. Design & Illustration: John Leighton* John Leighton (1822–1912) was one of the most prolific illustrators of his day. Besides books, he worked on bank notes, playing cards, magazine covers, photography, and most likely, sheet music. His initials can be seen on the lower center portion of this book. 17A **Griset's Grotesques; or, Jokes Drawn on Wood** *George Routledge & Sons, London. 1867. Illustration: Ernest Griset* The colored image within the oval is made of paper and has been glued in place, a method used from the 1850s into the 1870s. 17B **The Magic Spectacles: A Fairy Story** *Joseph R. Putnam, New York. 1868. Illustration: Chapman* 17C **The Prince of the Fair Family** *Chapman & Hall, London. 1867. Design & Illustration: John Leighton* John Leighton was founder of the *Graphic*, a popular illustrated magazine founded in 1869. His presence in the printed endeavors of the latter third of the 1800s is large (also see *Jingles & Jokes*, 16B).

18A 18B

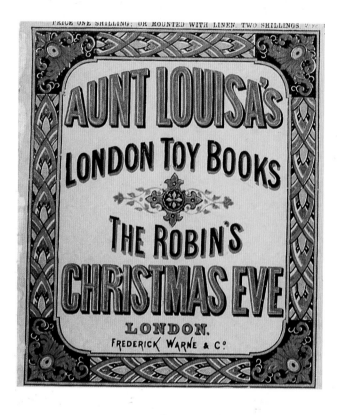

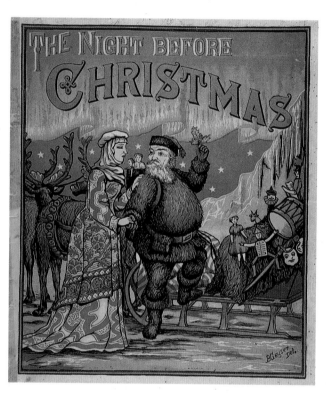

18A **The Robin's Christmas Eve** *Frederick Warne & Co., London. 1869* This, like many covers of this and the following decade, uses a fairground style, which was inspired by the decorations of carnivals and fairgrounds. 18B **The Night before Christmas** *Peter G. Thomson, Cincinnati. 1863. Illustration: B. Geyser* One of the rarest and most original versions of Moore's poem, this was also the first to use this title. 19 **The Child's Picture Book of Domestic Animals** *George Routledge & Sons, London. c. 1865* This is one of the few horizontal picture books of this era.

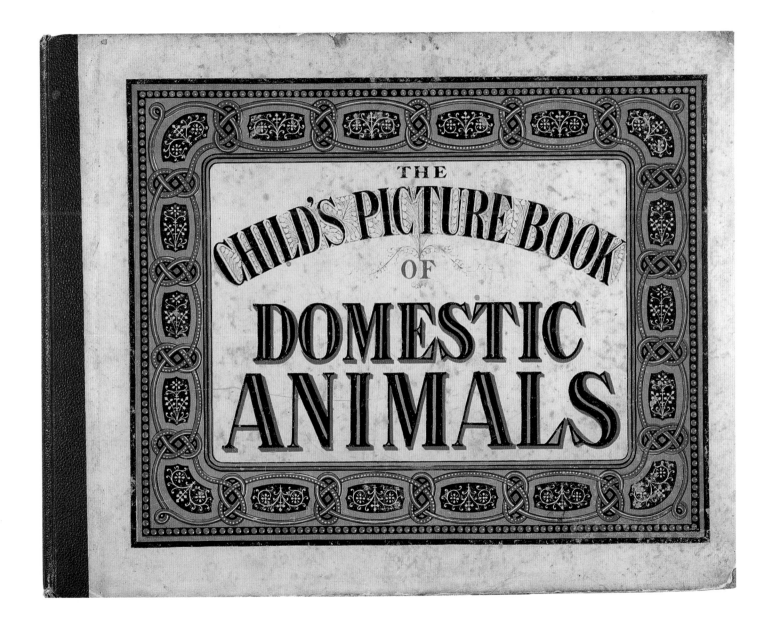

19

The
1870s

This decade unleashed a flood of creative energy into children's books, as displayed by their covers. Commonly, the period immediately following the conquest of technical obstacles is rich and experimental, and the problems of printing and binding books quickly and affordably were largely solved by the 1870s. The resultant freedom is manifest in the books and their covers. Furthermore, the English Education Act of 1870, which provided English schools with state support, greatly increased the number of children attending school, with a consequent rise in demand for children's books. Some of the great illustrators who were youthfully at work during this period were John Tenniel, Richard Doyle, Arthur Hughes, Ernest Griset, Walter Crane, Randolph Caldecott, and Kate Greenaway.

The most visible change in children's books during this period was the increasing use of pictures on their covers. Though they were sometimes used before this, the 1870s confirmed the tendency and set the direction for the future of children's book covers.

20 **The Little Market Woman** *W. P. Nimmo, Edinburgh. 1870s*

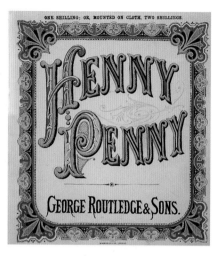

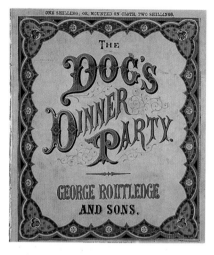

22A 22B
22C 22D

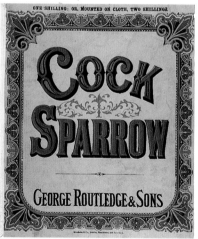

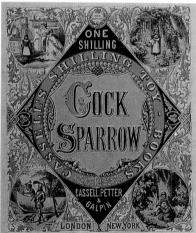

22A **Henny Penny** *George Routledge & Sons, London. 1870s* 22B **The Dog's Dinner Party** *George Routledge & Sons, London. c. 1870* Under the generic name "Toy Books," six- to eight-page color picture books proliferated in the late nineteenth century. Their single- (or sometimes two-) shilling prices made colored children's books more affordable. 22C **Cock Sparrow** *George Routledge & Sons, London. 1870s* 22D **Cock Sparrow** *Cassell, Petter & Galpin, London. c. 1870* This cover is unusual in that the four corners of the cover are used to advertise four other titles by Cassell, Petter & Galpin. 23A **Alphabet of Flowers** *George Routledge & Sons, London. c. 1875* The pictures in the four corners bear no relation to the contents. Relevance to the interior matter does not strongly control cover design in this period. 23B **The King, Queen, & Knave of Hearts** *Frederick Warne & Co., London. c. 1873* Most publishers of this era had a series of toy books named for a mythical aunt, uncle, or cousin. Frederick Warne's Aunt Louisa was quite prolific. Note at the top center that this is the thirtieth in the series.

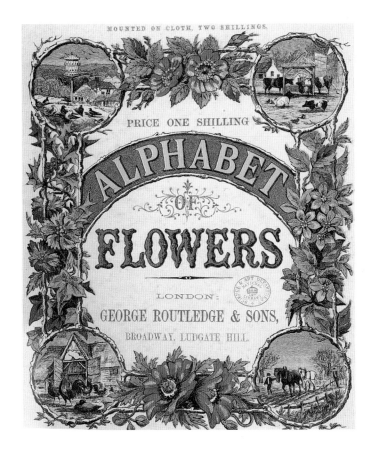

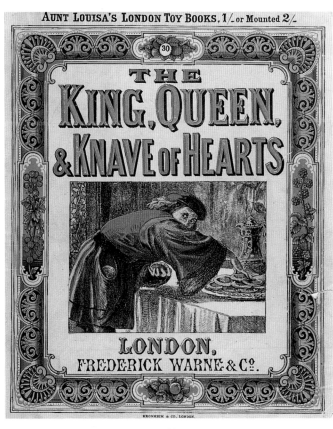

23A 23B

24

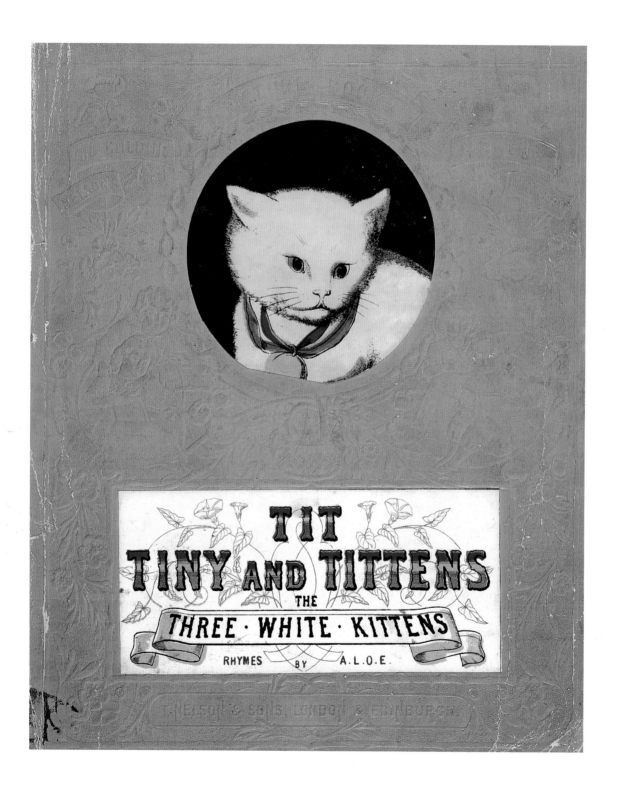

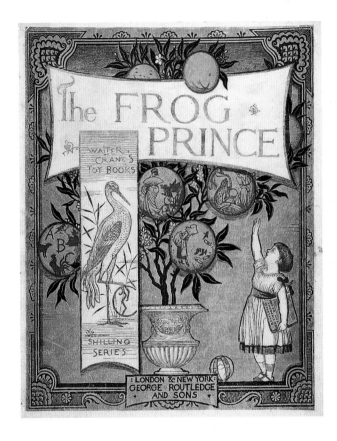

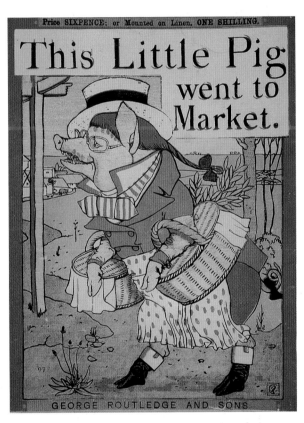

25A 25B

24 **Tit Tiny and Tittens: The Three White Kittens** *Thomas Nelson & Sons, London. 1870s* Embossed on the cover are the words: "Nelson's Oil Colour Picture Books for the Nursery." 25A **The Frog Prince** *George Routledge & Sons, London. 1874. Design & Illustration: Walter Crane* Four of the fruits advertise four of Crane's picture books. 25B **This Little Pig went to Market** *George Routledge & Sons, London. 1870. Illustration: Walter Crane; Design: Edmund Evans*

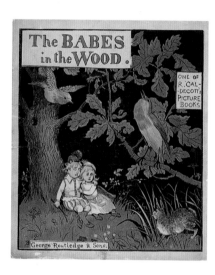

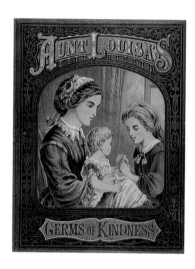

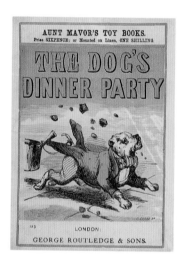

26A 26B 26C

26A **The Babes in the Wood** *George Routledge & Sons, London. 1879. Design & Illustration: Randolph Caldecott* 26B **Aunt Louisa's Germs of Kindness** *McLoughlin Bros., New York. 1870s* 26C **The Dog's Dinner Party** *George Routledge & Sons, London. 1870s. Illustration: Harrison Weir; Design: Edmund Evans* 27 **The House that Jack built** *George Routledge & Sons, London. 1878. Design & Illustration: Randolph Caldecott* Maurice Sendak in *Caldecott & Co.* (1988) says: "Caldecott's work heralds the beginning of the modern picture book. He devised an ingenious juxtaposition of picture and word, a counterpoint that never happened before. Words are left out—but the picture says it. Pictures are left out—but the word says it. In short, it is the invention of the picture book."

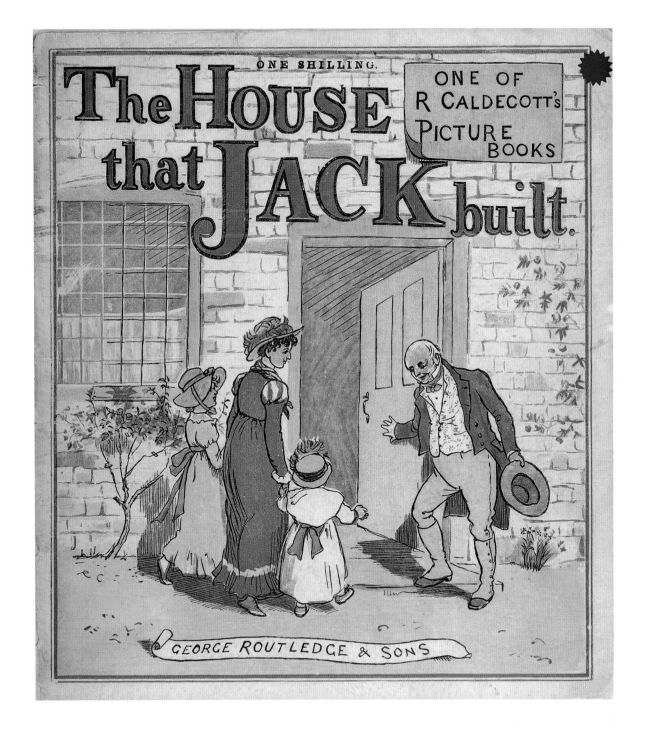

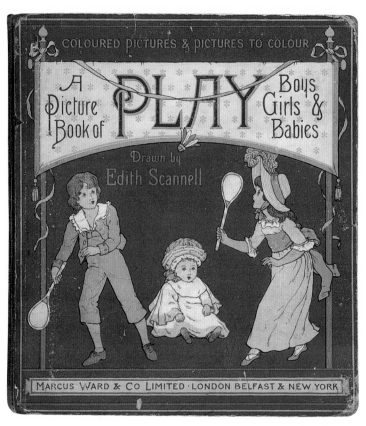

The
1880s

The tendencies begun in the 1870s continued and deepened during this ten years. Designers used color everywhere, and lettering is subordinated to image. Text, pattern, and pictures are freely integrated. However, Ruari McLean, the supreme authority on nineteenth-century book covers, sees this decade far less favorably: "In the 1880s, the character of illustrated children's books in Britain seems to change, and it is not a change, artistically speaking, for the better. There seem to be more and more wishy-washy books published by Ernest Nister and Raphael Tuck, mostly printed by chromolithography in Bavaria. Much of the artwork for these books and their bindings is by unnamed artists without much character—it contrasts unfavorably with the work of Crane, Caldecott and Greenaway, which was still being sold all this time" (*Victorian Publishers' Book-Bindings in Paper*, 1983).

Even though I have great respect for McLean's scholarship on illustrated books and book bindings, I cannot agree with this assessment. Wishy-washy books are in the majority in all eras and among all types of publications. Bavarian printers could be as good, or bad, as English printers, and chromolithography (a more elaborate form of stone lithography) was used equally in both nations. I find character frequent in the illustrations of this time, whether named or not. Finally, Caldecott, Crane, and Greenaway are such titanic figures that almost anyone compares poorly with them.

It is interesting to notice how isolated children's books are from the artistic crosscurrents of their time. William Morris's impact on the artistic life of the 1870s and 1880s was great, and yet there is little sign of his medievalism in the children's books of this period. Art Nouveau, which was altering almost everything else in the 1880s and 1890s, shows little of its sinuosity in the covers or the illustrations.

28 **Play: A Picture Book of Boys, Girls & Babies** *Marcus Ward & Co., London. 1884. Illustration: Edith Scannell* On this cover, two children appear to be playing badminton on the same side of the net. A baby sits dangerously close. The net makes a natural mast for the title.

30

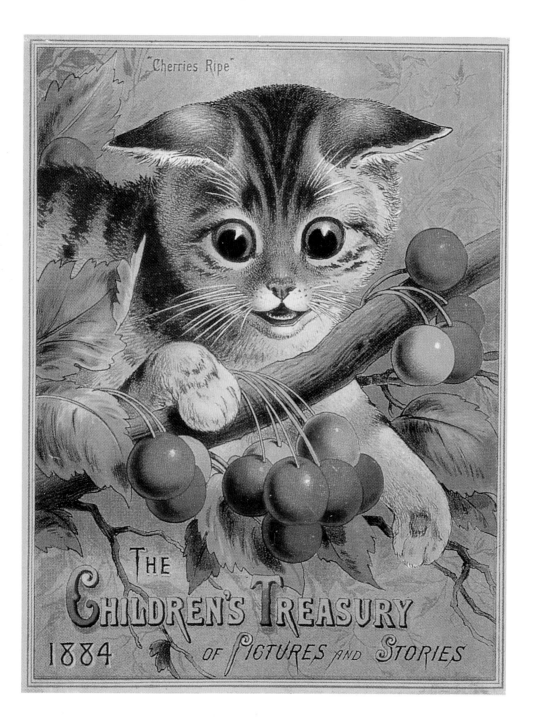

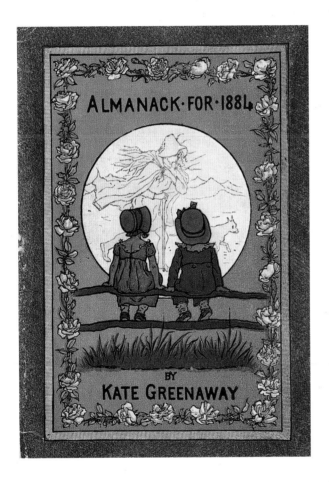

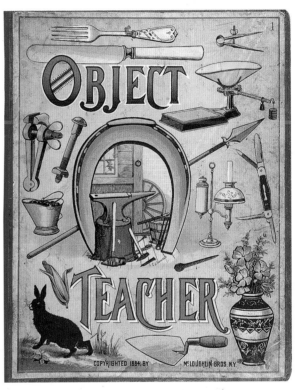

31A 31B

30 **The Children's Treasury of Pictures and Stories** *Thomas Nelson & Sons, London. 1884* 31A **Almanack for 1884** *George Routledge & Sons, London. 1884.*
Illustration: Kate Greenaway Kate Greenaway (1846–1901) created her small almanacs yearly from 1882 through 1894, and then for two later years. They were very popular, selling ninety thousand in 1894, for example. 31B **Object Teacher** *McLoughlin Bros., New York. 1884. Illustration: C. J. Howard*

32

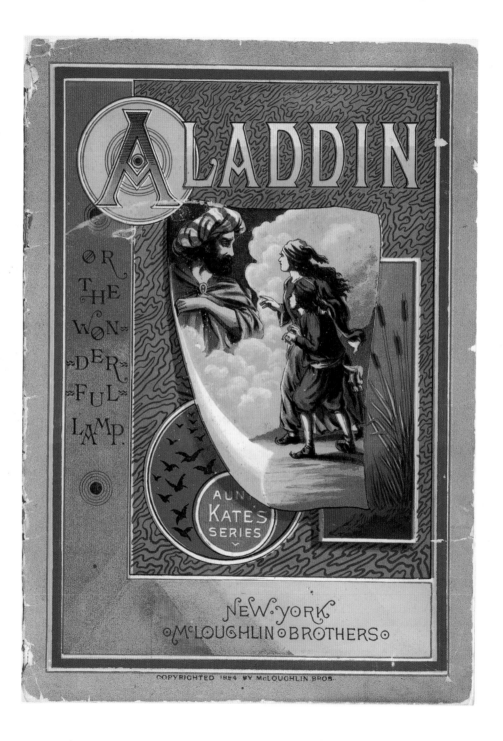

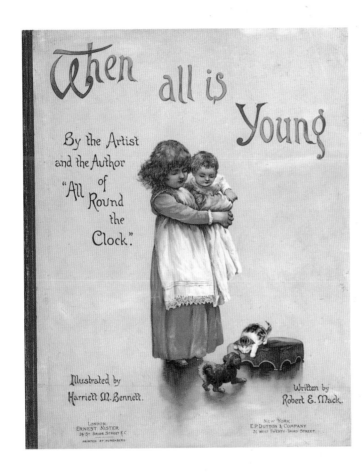

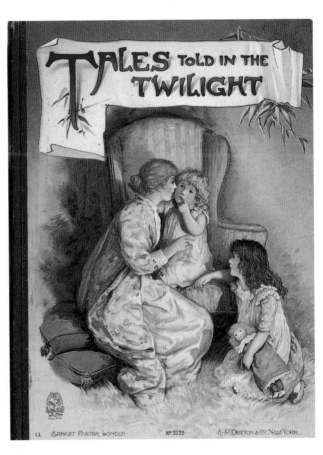

33A 33B

32 **Aladdin, or The Wonderful Lamp** *McLoughlin Bros., New York. 1884.* This is an early appearance of an American artist and publisher. 33A **When all is Young** *Ernest Nister, London, and E. P. Dutton & Co., New York. c. 1889. Illustration: Harriett M. Bennett* This English and American publishing partnership produced many wonderful illustrated books over the years. 33B **Tales Told in the Twilight** *Ernest Nister, London, and E. P. Dutton & Co., New York. 1880s Illustration: Lizzie Mack*

34A 34B 34C

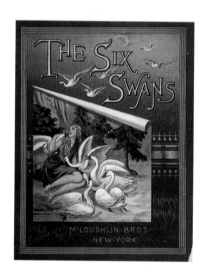
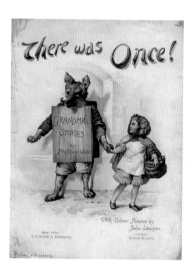
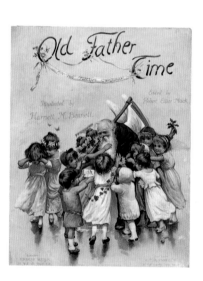

34A **The Six Swans** *McLoughlin Bros., New York. 1883* 34B **There was Once!** *E. P. Dutton & Co., New York. c. 1888. Illustration: John Lawson* 34C **Old Father Time and His Twelve Children** *Ernest Nister, London. 1880s. Illustration: Harriett M. Bennett* 35 **Gulliver's Travels in Brobdingnag** *McLoughlin Bros., New York. c. 1880*
John McLoughlin began publishing for children in New York in 1828. He and his sons produced books, toys, games, paper dolls, and many other products for more than one hundred years. McLoughlin's success through intelligent utilization of the latest printing techniques of the time helped U.S. picture book publishers establish an identity separate from their British parentage.

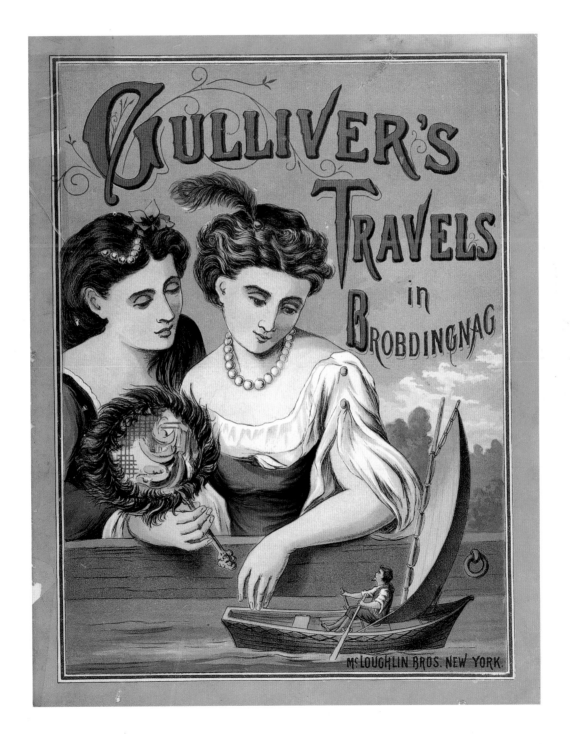

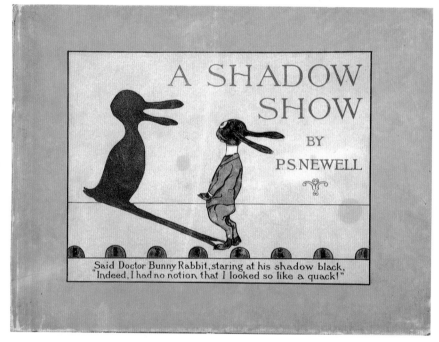

The
1890s

A s the century neared its end, there arose a sense of intellectual and artistic liberation. Book covers could go in any direction, designers could try any experiment; thus it is difficult to identify an 1890s cover by its appearance. It might seem to originate from a period twenty years earlier or one twenty years later. Printing historian Aymer Valance says that "never before had modern printing been treated as a serious art." The covers also were a more serious matter than they had been. Valance remarks: "The 1890s saw the emergence of a new school of binders who maintained that the cover of the book should prepare the reader for the contents by the means of designs incorporating pictorial elements." Even though this had been practiced for decades in children's books, a more widespread effort began in the 1890s to make books externally appealing. Books and articles on the aesthetics of trade bookbinding first appeared in the 1890s.

A Shadow Show *Century Co., New York. 1896. Design & Illustration: Peter Newell*

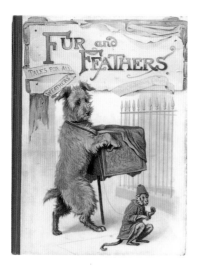

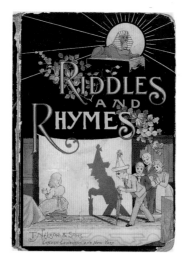

38A 38B
38C 38D

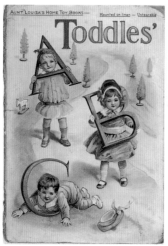

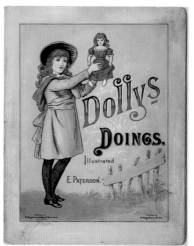

38A **Fur and Feathers: Tales for All Weathers** *Raphael Tuck & Sons, London. 1895. Illustration: Helena Maguire* 38B **Riddles and Rhymes** *Thomas Nelson & Sons, London. 1892* 38C **Toddles' ABC** *Frederick Warne & Co., London. 1890s* Linen books were heavily sized so as to be stiff like paper on board, unlike rag books, which were simply printed on floppy cloth (also see *The Doggie's Promenade*, page 56). 38D **Dollys Doings** *W. Hagelberg, London and New York. 1890s. Illustration: E. Paterson* This book was printed in Germany, as were many turn-of-the-century English picture books, probably because it was more economical to do so. 39 **Queerie Queers With Hands, Wings and Claws** *John D. Larkin, Buffalo. c. 1890. Design & Illustration: Palmer Cox* Palmer Cox was an American illustrator of great originality, who was best known for his Brownie books.

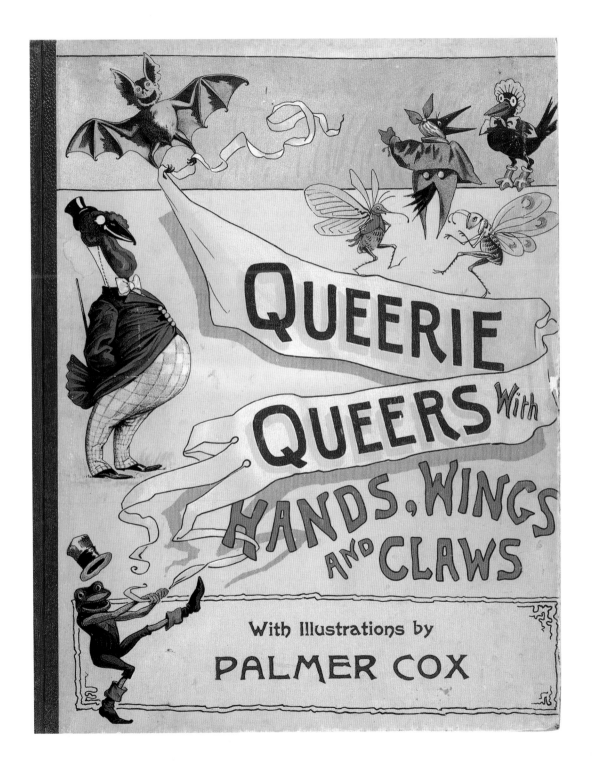

QUEERIE QUEERS with HANDS, WINGS AND CLAWS

With Illustrations by

PALMER COX

40

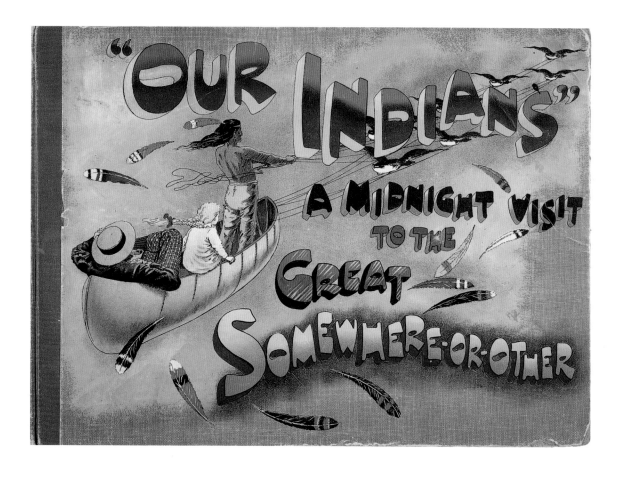

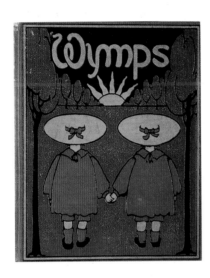

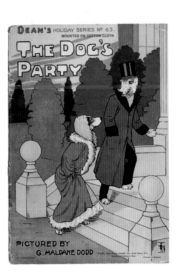

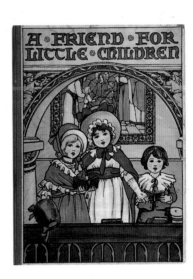

41A 41B 41C

40 **"Our Indians": A Midnight Visit to the Great Somewhere-or-other** *E. P. Dutton & Co., New York. 1899. Design & Illustration: L. D. Bradley* L. D. Bradley (1853–1917) illustrated only two children's books, but his imagination, illustrative skill, and talent for design and lettering put him among the elect. 41A **Wymps and Other Fairy Tales** *John Lane, The Bodley Head, London. 1897. Design & Illustration: Mrs. P. Dearmer (Mabel Dearmer)* 41B **The Dog's Party** *Dean & Son, London. 1890s. Illustration: G. Haldane Dodd* 41C **A Friend for Little Children, and Other Favourite Hymns for Children** *Henry Frowde and Hodder & Stoughton, London. 1890s*

42A 42B

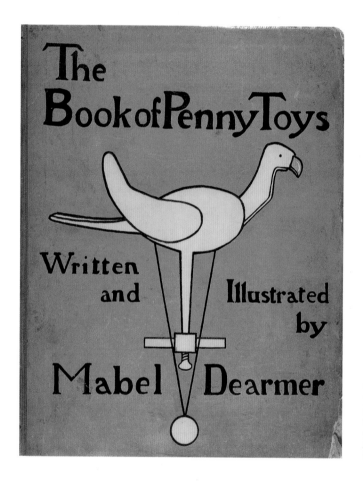

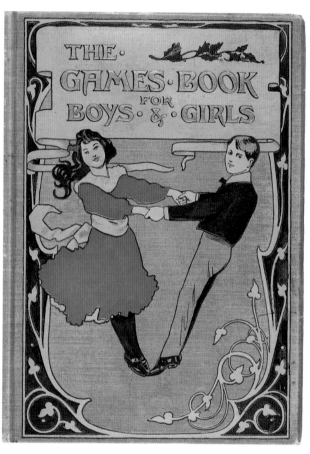

42A **The Book of Penny Toys** *Macmillan & Co., London. 1899. Design & Illustration: Mabel Dearmer* Mabel Dearmer was also a poster designer. The boldness and brightness of this cover show this design sensibility. 42B **The Games Book for Boys & Girls** *Ernest Nister, London. 1890s. Illustration: Edith Cubbit* 43 **Peeps into Zoo-land** *Frederick Warne & Co., London. 1890s* The felicity of hand lettering on the cover of old children's books is apparent here.

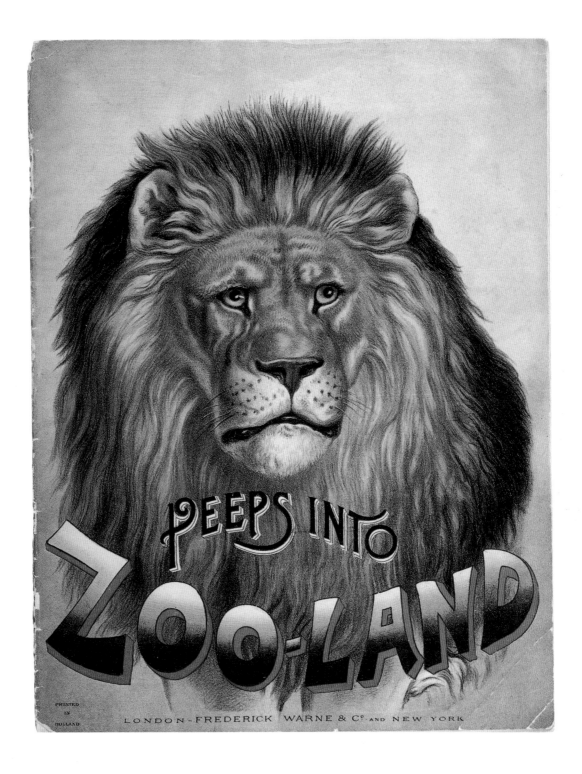

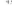

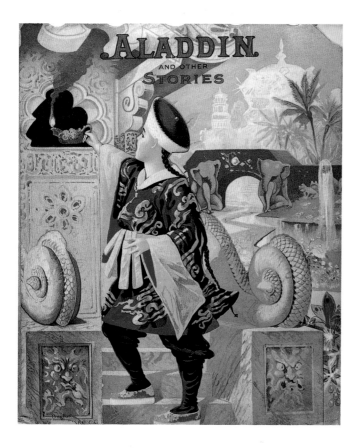

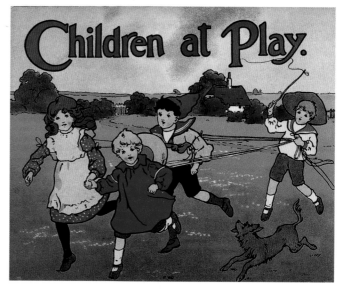

44A 44B

44A **Aladdin and Other Stories** *De Wolfe, Fiske & Co., Boston. 1890s* On this cover, Aladdin and the staircase are an attached flap of stiff card that moves slightly to the left to reveal a little more of the garden behind. One wonders why the publisher went to this trouble for such a slim effect—perhaps to help the book stand on its own. I do like the depth of this cover, whatever its intention. 44B **Children at Play** *n.p., Germany. 1890s. Illustration: Edith Cubitt* 45 **Jack the Giant Killer** *Macmillan & Co., London. 1898. Design & Illustration: Hugh Thomson* This is English artist Hugh Thomson's (1860–1920) only children's book cover. The type and image are well integrated, with the title banner cleverly concealing most of the giant, thereby piquing our interest. All of this, and more, make me wish that the series had been continued.

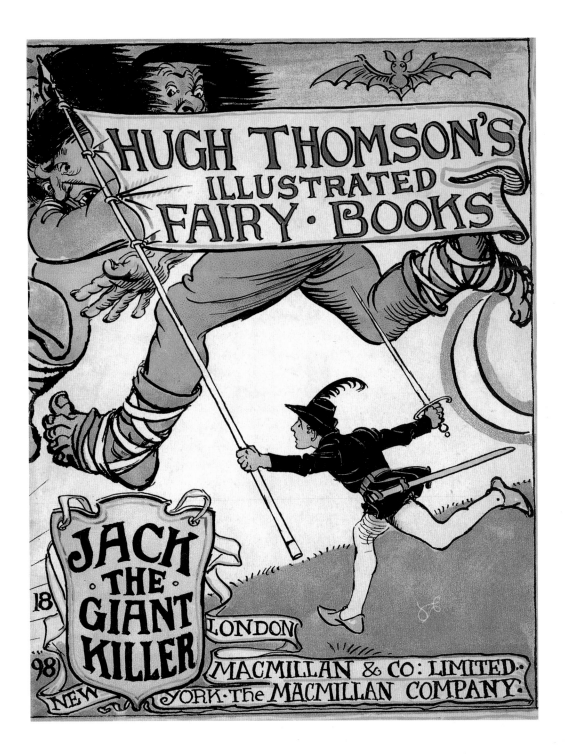

The
1900s

The turn of the century began the dominance of four-color process printing over the older methods of wood-carved or stone-etched blocks. This change involved, on the whole, an increase in tonal subtlety and a decrease in graphic force.

The comic strip, born late in the nineteenth century, soon became very popular. It changed children's book illustration by encouraging caricature, quick sketching, and storytelling through closely collected sequences of images.

Childhood became, during this decade, a popular consumer trend. There were more juvenile books published than ever before, and as demand increased, publishers were willing to take chances with a wider and stranger range of subjects and styles of illustration. Earlier children's books emphasized learning, moral instruction, and activities that the authors imagined children would enjoy. Now the child takes center stage.

46 **Gammon and Spinach** *Blackie & Son, London. 1901. Design & Illustration: Stewart Orr*

48A 48B 48C

 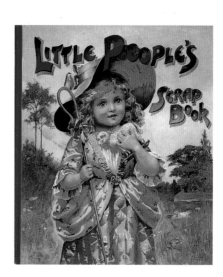

48A What Is This? An Object Book for very little folk *Frederick Warne & Co., London. 1900s* Object books feature close-up images of the objects of daily life. They are directly descended from *Orbis Sensualium Pictus*, published in 1658 by Comenius, which was the first picture book for children. **48B The Babes in the Wood** *Blackie & Son, London. 1900s. Design & Illustration: Frank Adams* **48C Little People's Scrap Book** *Ernest Nister, London. c. 1902* **49 Merry Moments** *Ernest Nister, London. c. 1901. Illustration: Eveline Lance*

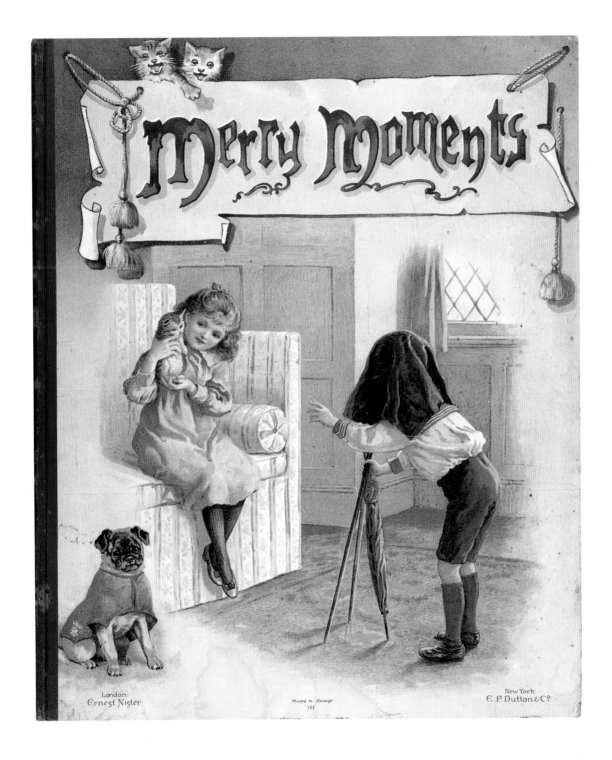

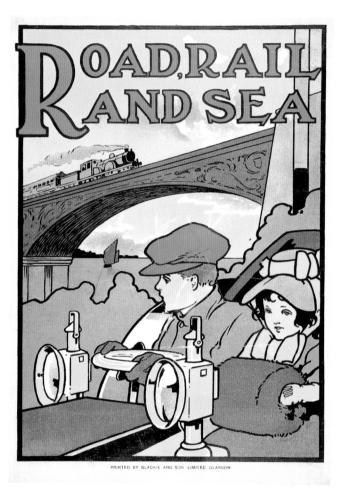

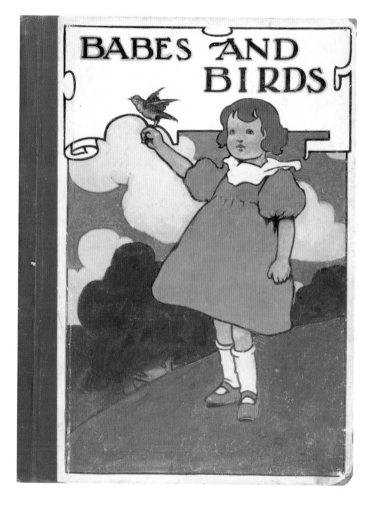

50A 50B

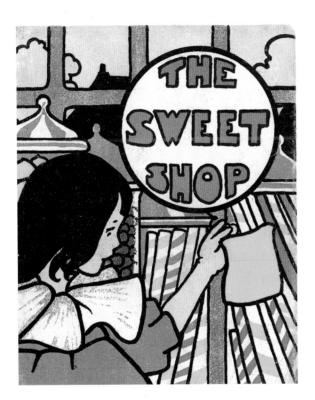

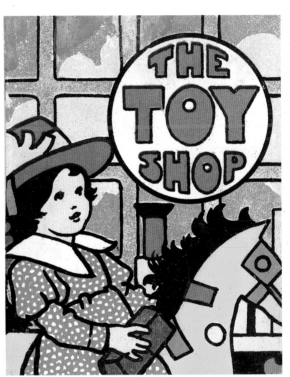

51A 51B

50A **Road, Rail and Sea** *Blackie & Son, London. 1906. Illustration: Charles Robinson* This cover successfully incorporates its three title subjects. 50B **Babes and Birds** *H. M. Caldwell Co., New York. c. 1909. Design & Illustration: Charles Robinson* Two other books in this very graphic series are *Babes and Blossoms* and *Babes and Beasts.* 51A **The Sweet Shop** *Blackie & Son, London. 1907. Design & Illustration: Charles Robinson* This book and *The Toy Shop* are very small, measuring 2¼ by 3¼ inches. Their simple force is startling in books of this size (also see *The Cake Shop*, page 173). 51B **The Toy Shop** *Blackie & Son, London. 1907. Design & Illustration: Charles Robinson*

52A 52B

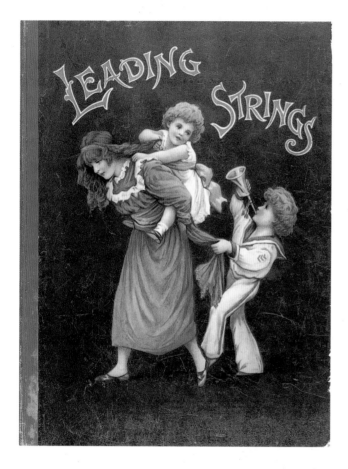

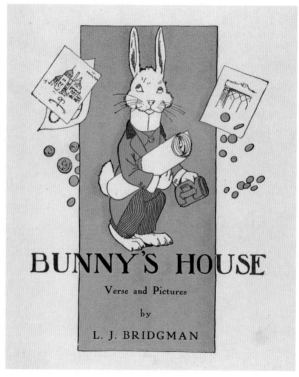

52A **Leading Strings** *Wells, Gardner, Darton & Co., London. 1902* 52B **Bunny's House** *H. M. Caldwell, Boston. 1900. Design & Illustration: L. J. Bridgman* 53 **The Owl and the Woodchuck (With a Few Others)** *Rand McNally & Company, Chicago. 1901. Design & Illustration: Walter Bobbett* The careless lettering (presumably accomplished by the animal characters) is just right.

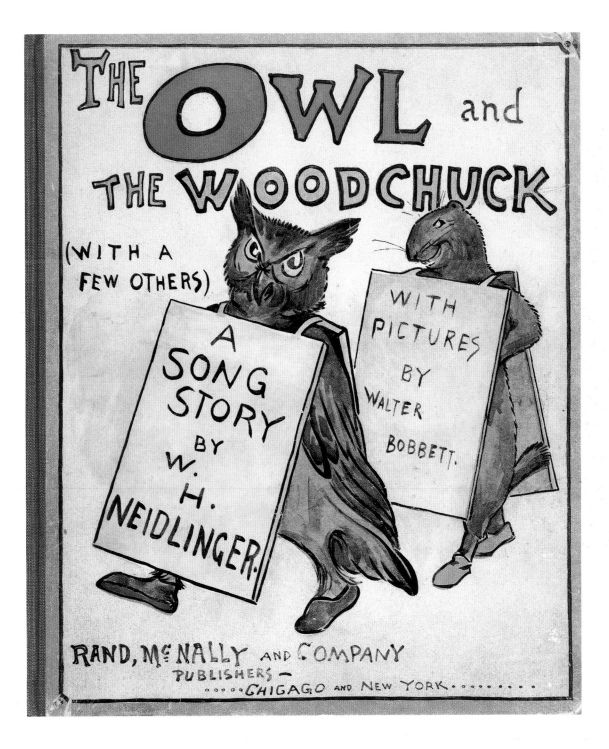

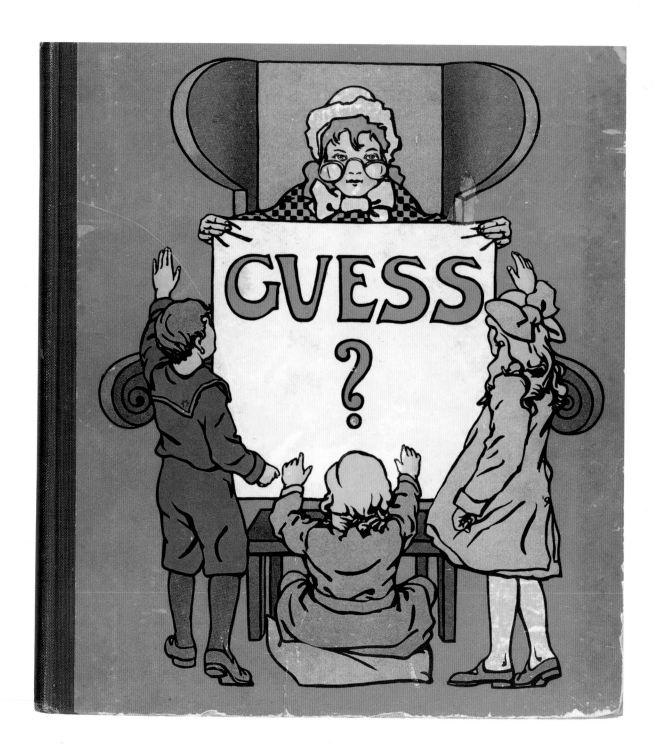

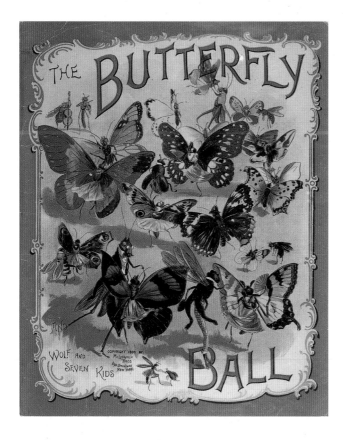

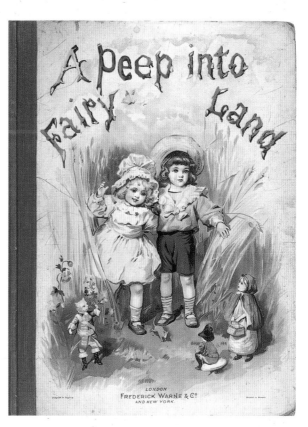

55A 55B

54 **Guess?** *Dodge Publishing Co., New York. 1901. Design & Illustration: L. J. Bridgman* L. J. Bridgman (1857–1931), who appears here and on page 52, was a prolific and innovative illustrator. 55A **The Butterfly Ball** *McLoughlin Bros., New York. 1900* The idea of an insect soirée had been popular ever since a poem titled *The Butterfly's Ball and the Grasshopper's Feast* was published in 1806. 55B **A Peep into Fairy Land** *Frederick Warne & Co., London. 1900s. Illustration: E. F. and C. Manning*

56

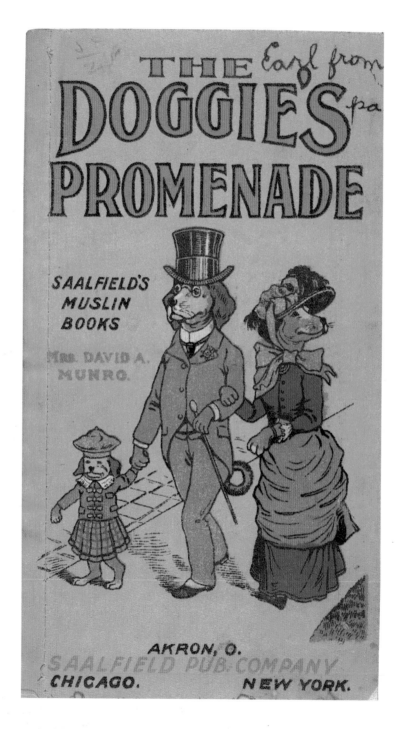

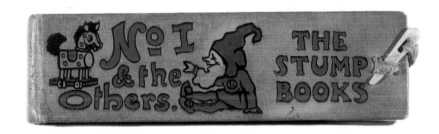

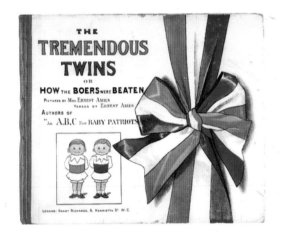

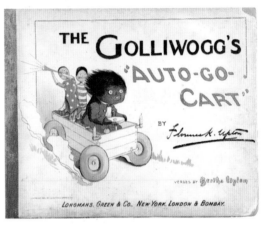

57A

57B 57C

56 **The Doggie's Promenade** *Saalfield Publishing Co., Akron, Ohio. 1907. Illustration: Mrs. David A. Munro* Floppy cloth books were called rag books in England and muslin books in the United States. 57A **No. 1 & the Others: The Stump Books** *Anthony Treherne & Co., London. 1900s. Illustration: Jean C. Archer* This book is 1½ by 6 inches wide and 1 inch thick, making it very graspable in the hand. It has a small bone clasp to keep it closed. Altogether it's a very personable book, and one of a series of seven. 57B **The Tremendous Twins, or How the Boers Were Beaten** *Grant Richards, London. 1900. Design & Illustration: Mrs. Ernest Ames* This is an early and interesting example of a trompe l'oeil cover. 57C **The Golliwogg's "Auto-Go-Cart"** *Longmans, Green & Co., New York. 1901. Design & Illustration: Florence K. Upton* The Golliwogg is a kind and wise character despite some of the unfortunate associations with his name. He and his friends, the two Dutch dolls, appeared in popular turn-of-the-century children's books by mother and daughter team Florence and Bertha Upton.

The 1910s

The most remarkable aspect of children's books of these years is not what they show but what they do not show. Modernism in the arts was, by this decade, fully focused. Technology had changed our ways of looking at the world, and artists reflected these changes. The telegraph joined continents. The telephone put us in close contact with one another. The automobile shrunk distances and encouraged mobility. Science and technology fractured the idea of the world as fixed and static. Cubism, abstractionism, expressionism, and futurism were various manifestations of these altered perspectives. The First World War changed many people's way of looking at life. It was the first global war, and was fought with technologies that had made killing easier, and mass communication made everyone aware of its terrors. Optimism and confidence were hard to maintain.

Children's books are remarkably free of these influences. *Our Air Ship A·B·C* (page 62) is the only book we include that hints at this larger world. As far as children were concerned, the world was still the prosperous, secure place that it had seemed in the late Victorian era.

58 **Buster Brown at Play** *Dean & Son, London. 1915. Illustration: R. F. Outcault*

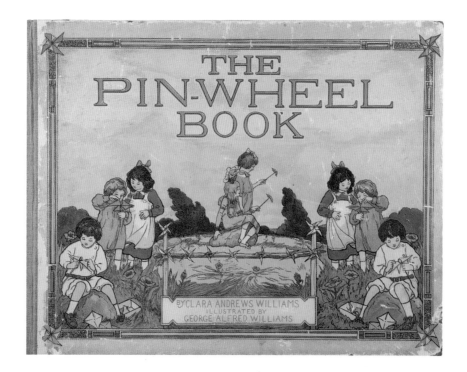

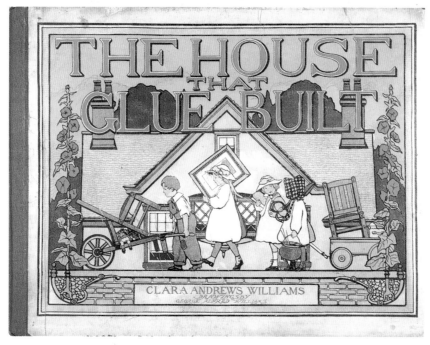

60A
60B

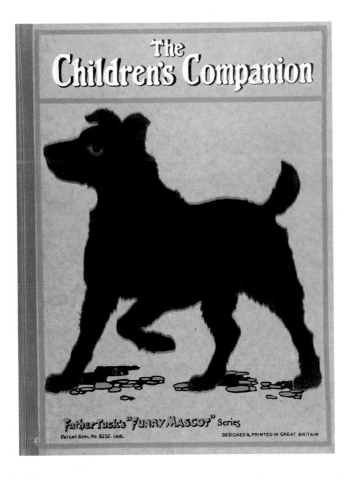

60A **The Pin-Wheel Book** *Frederick A. Stokes Co., London. 1910. Design & Illustration: George Alfred Williams* 60B **The House that Glue Built** *W. & R. Chambers, Edinburgh. c. 1910. Design & Illustration: George Alfred Williams* These two books have pictures that are intended to be cut and reassembled. Pinwheels and children are cut out and placed in landscapes. In the house book, various rooms are furnished with furniture, and people are cut from other pages and pasted down. 61 **The Children's Companion** *Raphael Tuck & Sons, London. 1915* The dog on this cover has a furry cloth body, encouraging the child's engagement through touch. It's a precursor of *Pat the Bunny* by twenty-five years (also see *Miss Sniff, the Fuzzy Cat*, page 102).

62

62 **Our Air Ship A·B·C** *Raphael Tuck & Sons, London. 1912* Then, as now, the technical achievements of the day were translated into the nursery. Note how *Our Air Ship* deftly floats with the ships as *A·B·C* solidly holds to the earth, as befits its stolid reputation. 63 **Father Tuck's Merry Times Painting Book** *Raphael Tuck & Sons, London. 1914* This palette-shaped cover ingeniously approximates its real-life model. The brush at far right is removable, and the paints are attached to the back cover and accessed, at every page, through die-cut holes. One can easily imagine the child playing artist.

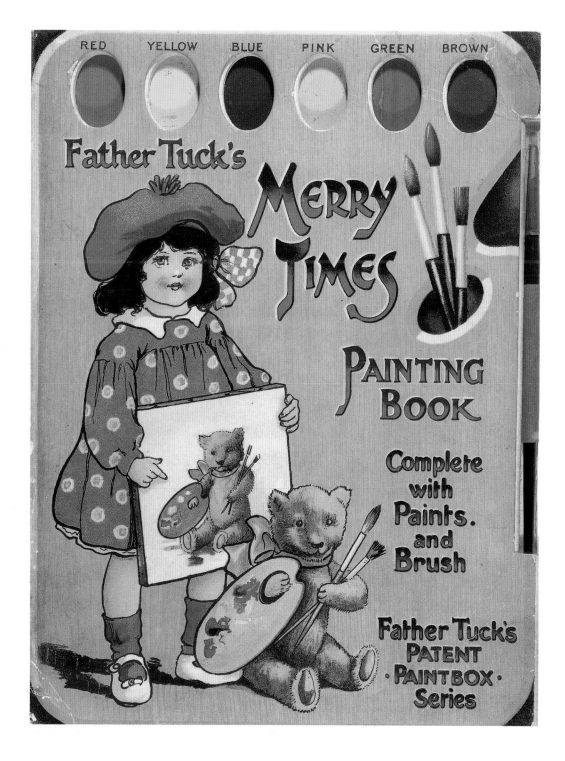

64A
64B

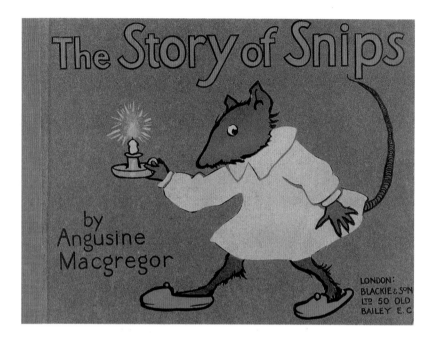

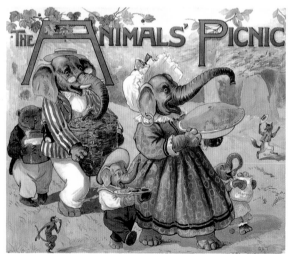

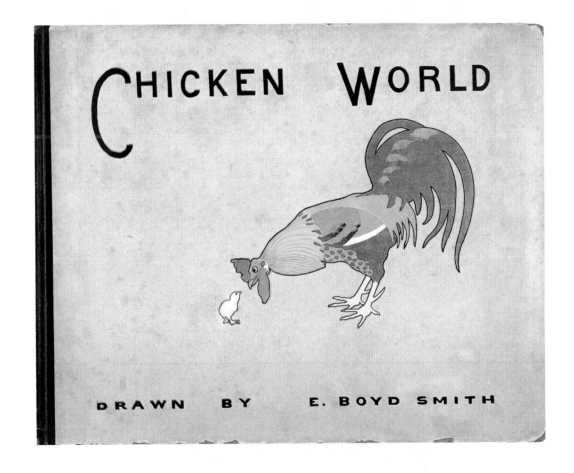

64A **The Story of Snips** *Blackie & Son, London. 1910s. Design & Illustration: Angusine Macgregor* The gray paper is a perfect night background for the colored printing of the simple forms. 64B **The Animals' Picnic** *Ernest Nister, London. c. 1911. Design & Illustration: G. H. Thompson* 65 **Chicken World** *G. P. Putnam's Sons, New York. 1910. Design & Illustration: E. Boyd Smith* Canadian-born E. Boyd Smith (1860–1943) wrote and illustrated a number of children's books whose subject was rural America at the turn of the century. This simple cover and title tell us definitively what the book is about.

66

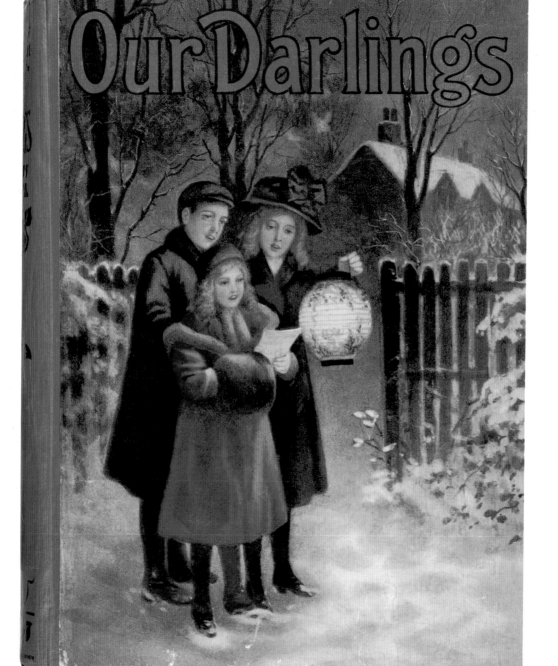

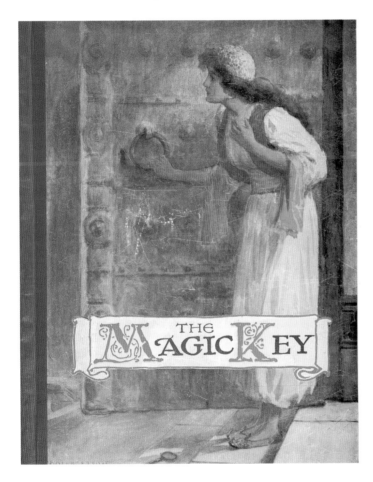

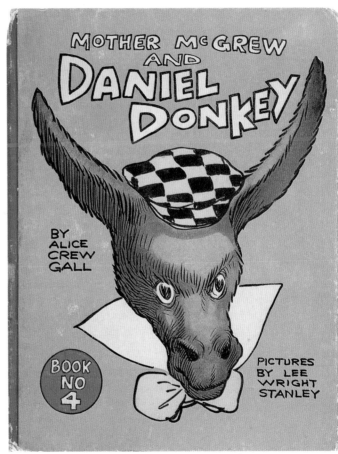

67A 67B

66 **Our Darlings** *John F. Shaw & Co., London. c. 1913* 67A **The Magic Key** *Thomas Nelson & Sons, London. 1910s. Illustration: H. Margetson* Book covers that picture doors and other portals naturally invite us to enter the book. 67B **Mother McGrew and Daniel Donkey** *Goldsmith Publishing Co., Cleveland. 1917. Illustration: Lee Wright Stanley*

68A 68B

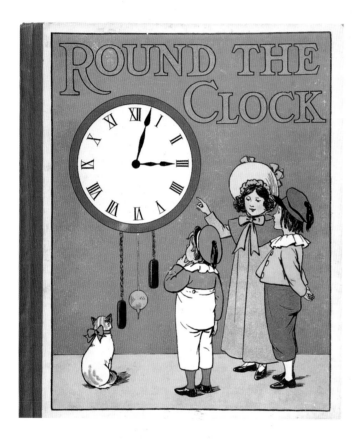

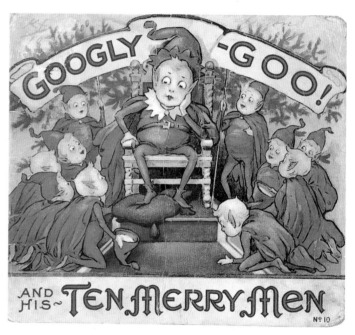

68A **Round the Clock** *Blackie & Son, London. c. 1910. Illustration: Elise H. Stewart* The cover of this book tells us what its function is without the obvious "How to . . .".
68B **Googly-Goo! and His Ten Merry Men** *Stecher Lith. Co., Rochester, New York. 1916. Illustration: W. F. Stecher* 69 **Brownikins and other Fancies** *Wells, Gardner, Darton & Co., London. 1910. Design & Illustration: Charles Robinson*

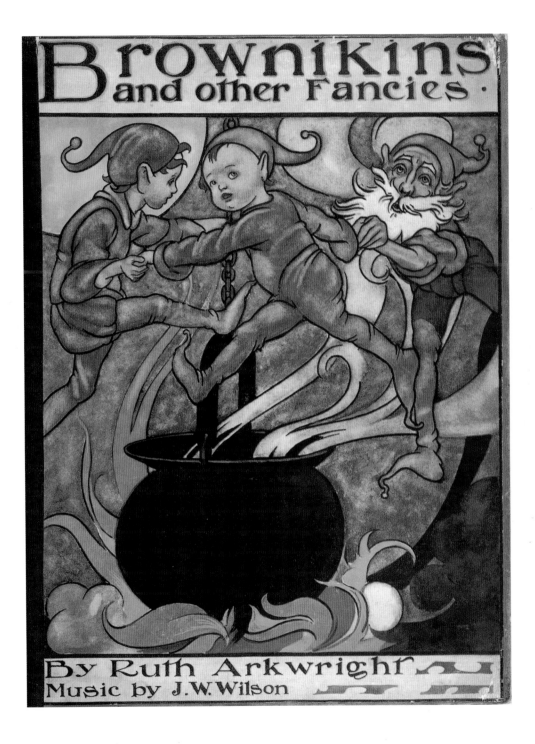

69

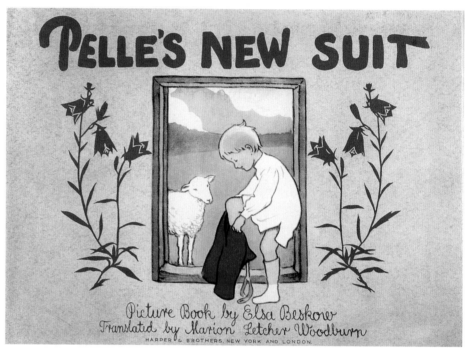

The
1920s

The decade following the conclusion of the Great War, with its consequent disillusion, was a time of restless pursuit of pleasure. Traditional points of view—whether in art, politics, or morality—were shaken by a groundswell of enthusiasm for new ways of being. Art Deco was born—according to graphic scholars Steven Heller and Seymour Chwast in *Graphic Style from Victorian to Post-Modern* (1988)—as an alternative to the dying Art Nouveau and the increasingly abstract Modernism. The Bauhaus, which was founded in 1919, asserted that all the arts be organized under the umbrella of architecture and be taught and practiced as crafts. The Bauhaus had a great impact in its advocacy of simple forms designed for effective function.

Again, children's books seem to exist in isolation from the intellectual and artistic crosscurrents of their time. As people try to isolate their children from unpleasant realities, so children's books usually reflect dreams, ideals, and fantasy. A close search would find some books that do mirror adult concerns, but our selection, which emphasizes memorable appearance, reveals how old-fashioned most books were. *Skeezix at the Circus* (page 74) shows the relative contemporaneity of the world of comic strips, from which this book was drawn.

70 **Pelle's New Suit** *Harper & Bros., New York. 1929. Design & Illustration: Elsa Beskow* Elsa Beskow (1874–1953) was, and is, the preeminent Swedish illustrator of children's books, and many Scandinavian immigrants to the United States delighted in her vision. May Arbuthnot, author of *Children and Books* (1947), said that this book was "as spare of ornamentation as a loaf of bread, but like bread, it is good to the taste, plain, wholesome and nourishing." This cover reflects that character.

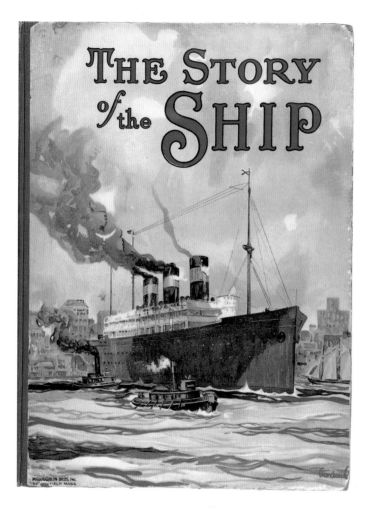

72A 72B

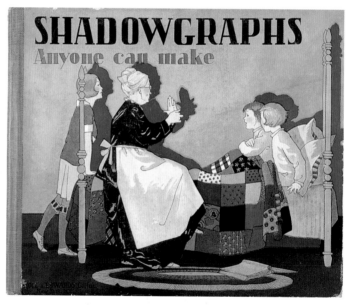

72A **The Story of the Ship** *McLoughlin Bros., New York. c. 1920. Illustration: Gordon Grant* 72B **Shadowgraphs Anyone can make** *Stoll & Edwards Co., New York. 1927. Illustration: Phila H. Webb* The interior of this book is dull. All the artistic effort of the publisher has gone into the cover. The practice of attaching enticing covers to mundane texts is timeless and, while not altogether honest, it has provided some pleasure for the cover aficionado. 73 **The Bluebell Story Book** *Blackie & Son, London. 1923. Design & Illustration: Cicely Mary Barker* Cicely Barker (1895–1973) makes this cover compelling by the beauty of the image and by how close she brings the viewer.

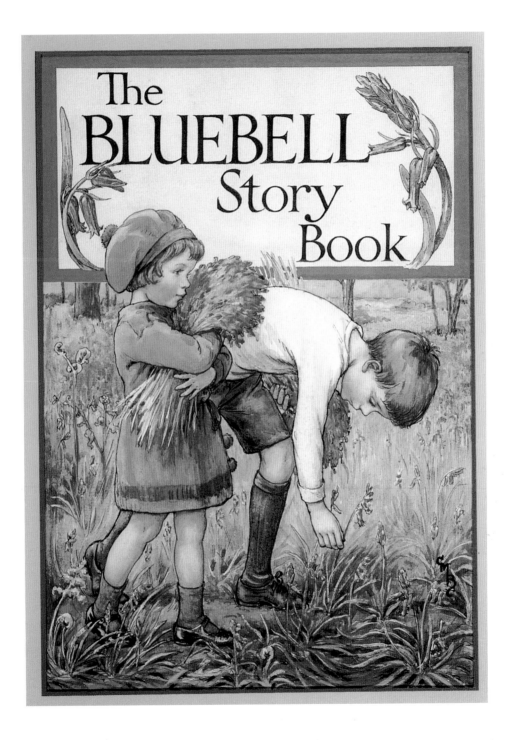

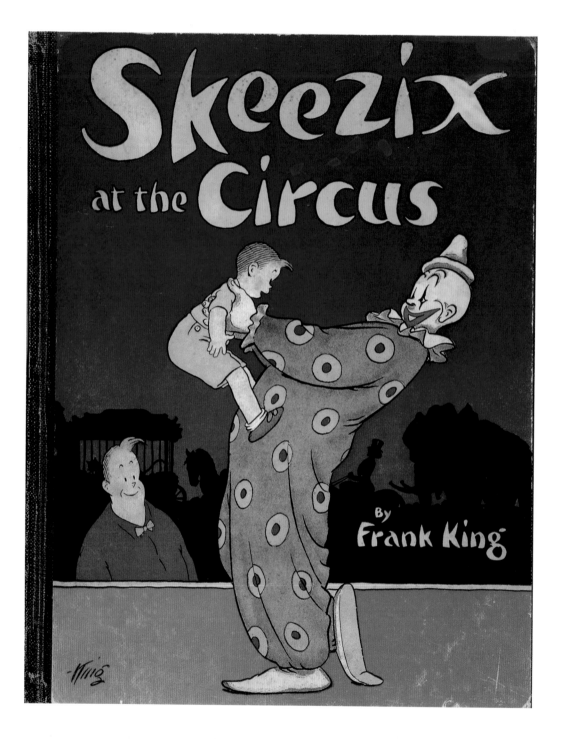

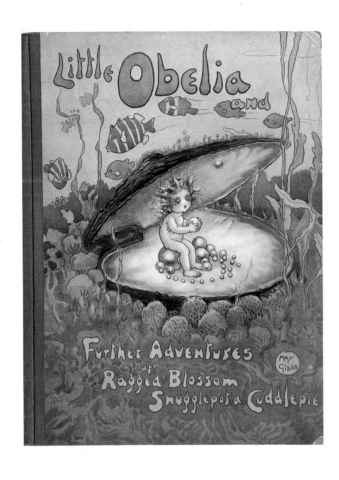

74 **Skeezix at the Circus** *Reilly & Lee Co., Chicago. 1926. Design & Illustration: Frank King* Skeezix was a popular comic strip character in the 1920s. 75 **Little Obelia and Further Adventures of Ragged Blossom, Snugglepot & Cuddlepie** *Angus & Robertson, Sydney. 1921. Design & Illustration: May Gibbs* May Gibbs (1877–1969) was a beloved and best-selling Australian children's book author.

76

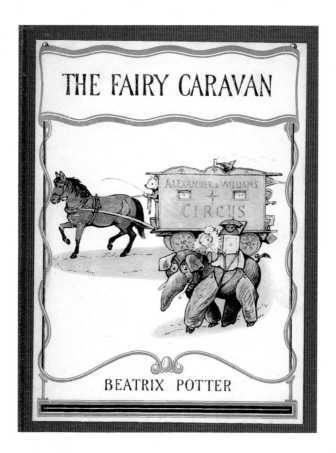

76 **The Fairy Caravan** *David McKay Co., Philadelphia. 1929. Illustration: Beatrix Potter* Long after she retired from making books, Beatrix Potter (1866–1943) made this book for an American publisher and American audience. It was not published in Britain until 1951. 77 **The Remarkable Tale of a Whale** *P. F. Volland Co., Chicago. 1920. Illustration: John Held, Jr.* John Held (1889–1958) was a prolific illustrator, most notably in *Life,* the *New Yorker, Judge, College Humor,* and *Vanity Fair.* His jaunty insouciance helped shape the spirit of the twenties.

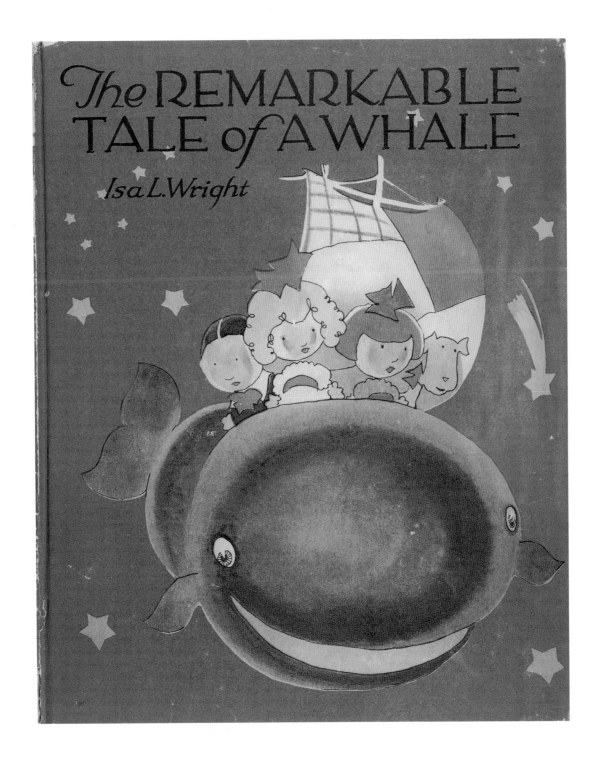

78A 78B

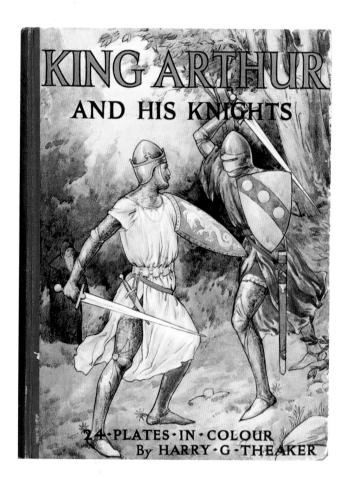

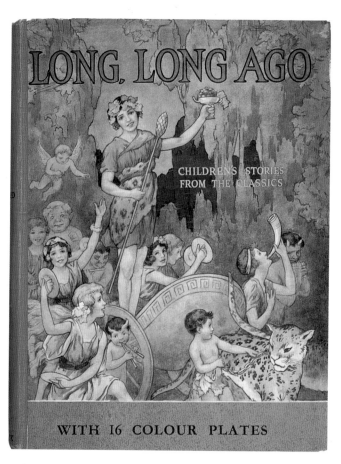

78A **King Arthur and His Knights** *Ward, Lock & Co., London. c. 1925. Illustration: Harry G. Theaker* 78B **Long, Long Ago** *Ward, Lock & Co., London. c. 1928. Illustration: Harry G. Theaker* 79 **The Dreamland Express** *Dodd, Mead & Co., New York. 1927. Design & Illustration: H. R. Millar* This cover makes the viewer want to board the Dreamland Express.

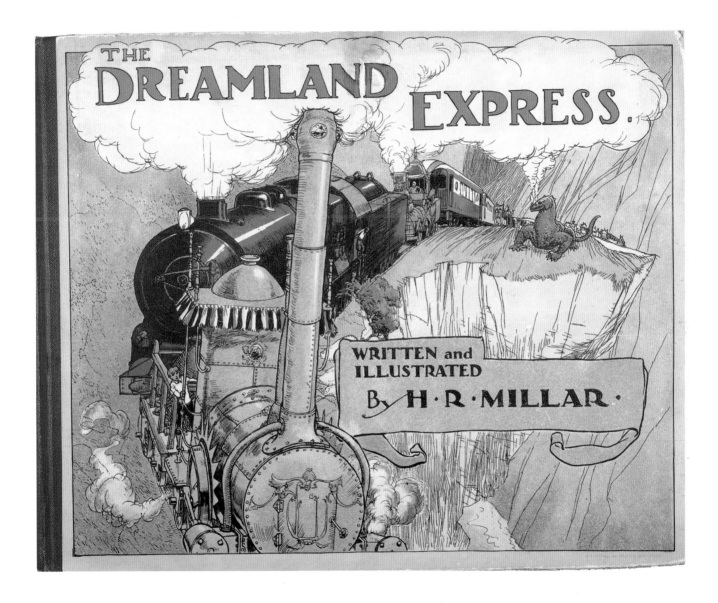

80A 80B

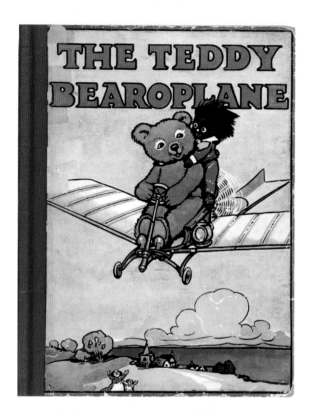

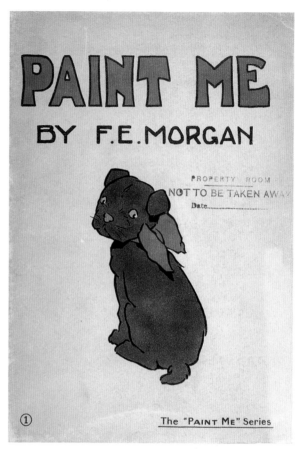

80A **The Teddy Bearoplane** *Henry Frowde and Hodder & Stoughton, London. 1920s. Illustration: J. R. Sinclair* 80B **Paint Me** *Frederick Warne & Co., London. 1920s.*
Illustration: F. E. Morgan The dog pleads with us to buy, and then to open this book and paint. 81 **Ward, Lock & Co.'s Wonder Book** *Ward, Lock & Co., London. 1926.*
Illustration: Honor Appleton In this cover, Honor Appleton (1879–1951) brilliantly illustrates the "wonders" available within the book. Appleton successfully personifies
imagination and shows us the transfixion of a child daydreaming as reality fades into the background.

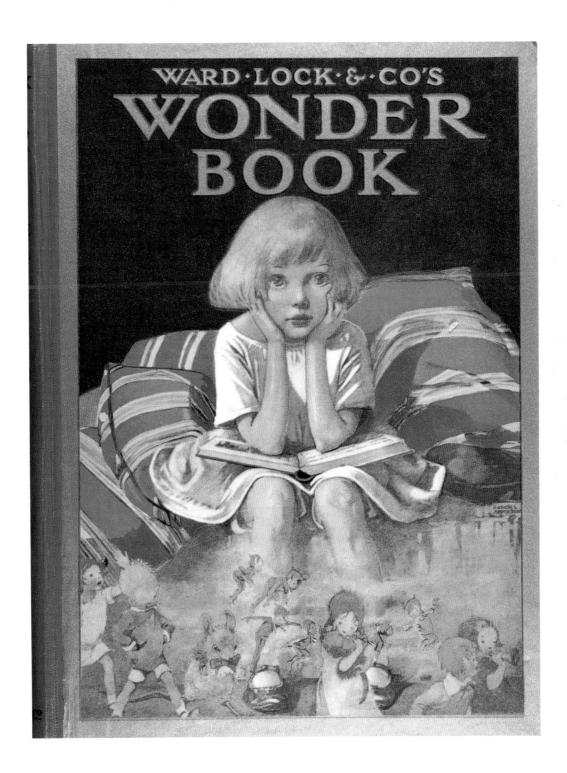

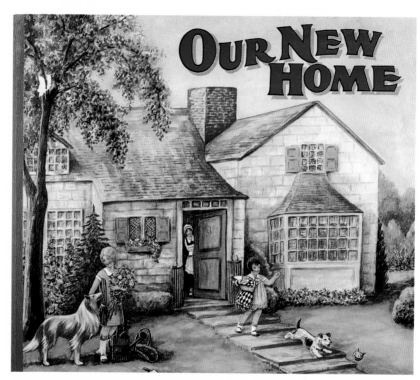

The 1930s

By the 1930s the persistent design tendency toward simplicity finally made an impact on children's book covers. Jan Tschichold, in his epochal *The New Typography* (1928), argued for sans serif type, asymmetrically arranged, as the page design most suitable to the times. The covers in this section are about evenly divided between serif and sans serif type, whereas those in the previous decade are almost all serif. *Hansi* (page 88) and *Adventures in a Dishpan* (page 91) demonstrate the spirit of Modernism more fully than any earlier books I have shown. Due to the worldwide economic depression, smaller sizes and cheaper materials could be expected in children's books, and I do indeed find in my collection more paperbound books than in earlier times (both books on pages 84 and 85 are bound in paper).

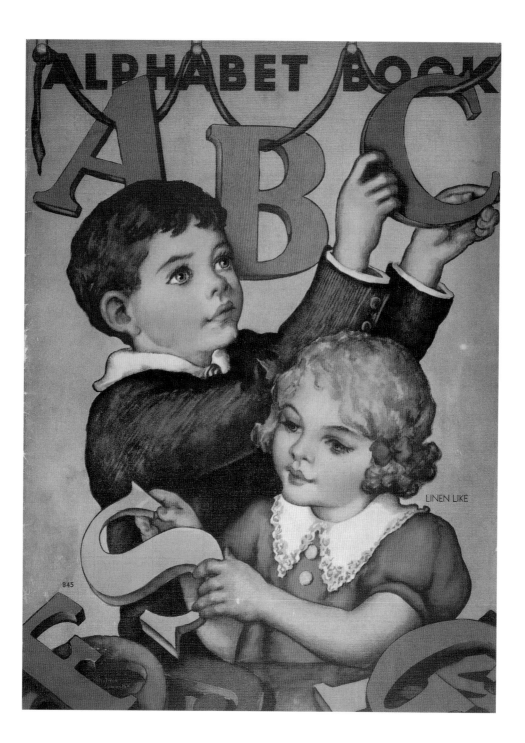

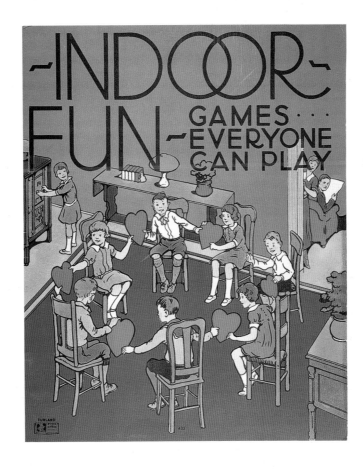

85

84 **Alphabet Book ABC** *Whitman Publishing Co., Racine, Wisconsin. 1939. Design & Illustration: Thelma Green* The tangibility of the letters makes this cover a persuasive invitation. 85 **Indoor Fun—Games Everyone Can Play** *Einson-Freeman Co., Long Island, New York. 1935*

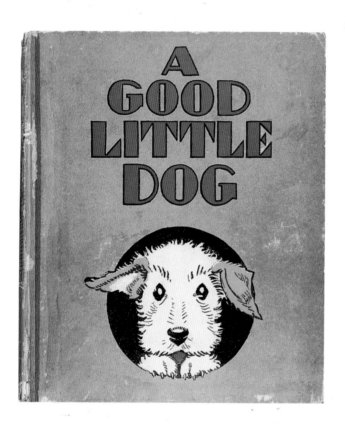

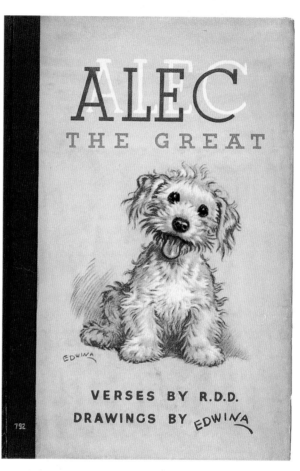

86A **A Good Little Dog** *Century Co., New York. 1930. Design & Illustration: Berta and Elmer Hader* One would have to be hard-hearted to resist an opportunity to better know this good dog. 86B **Alec the Great** *Whitman Publishing Co., Racine, Wisconsin. 1933. Illustration: Edwina* 87 **Cowboys of America** *Rand McNally & Co., New York. 1937. Design & Illustration: Sanford Tousey* Sanford Tousey knew how to appeal to a boy's hunger for adventure with his Technicolor dramatics.

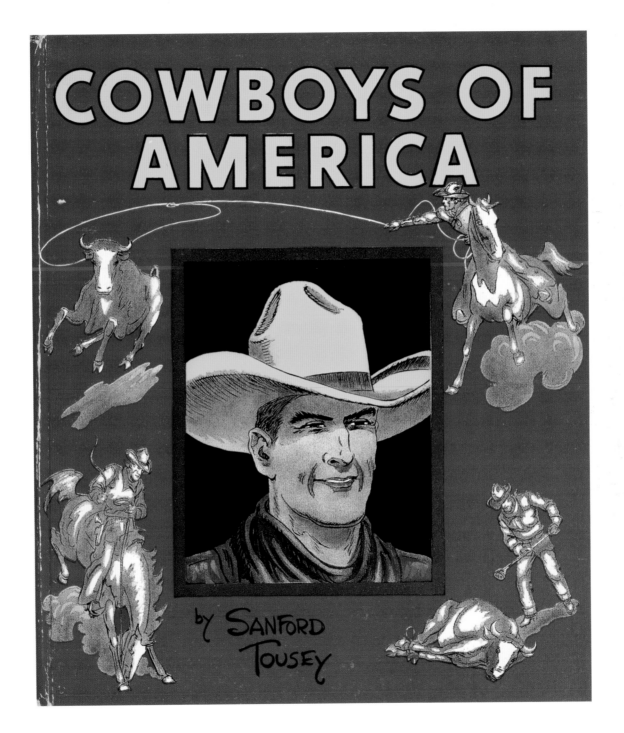

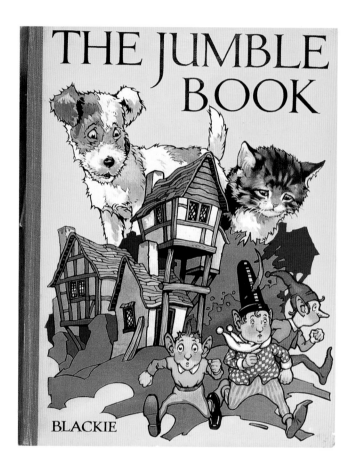

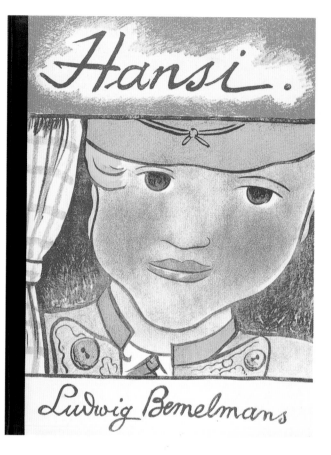

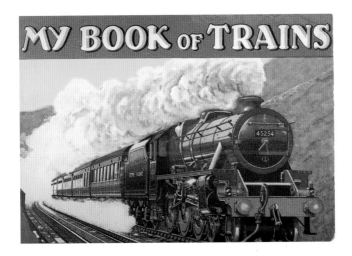

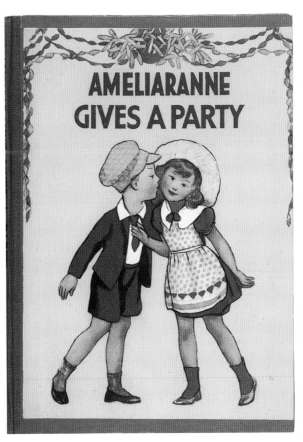

88A **The Jumble Book** *Blackie & Son, London. c. 1934. Illustration: C. E. B. Bernard & A. E. Kennedy* 88B **Hansi** *Viking Press, New York. 1934. Design & Illustration: Ludwig Bemelmans* Ludwig Bemelmans (1898–1962) brought a modernist sensibility to book illustration. His line is bold and free, like Picasso's or Calder's. His proportions are bizarre, the boy's head appearing almost as large as the window. 89A **My Book of Trains** *n.p., n.p. 1930s.* 89B **Ameliaranne Gives a Party** *George G. Harrap & Co., London. 1938. Illustration: Susan Beatrice Pearse*

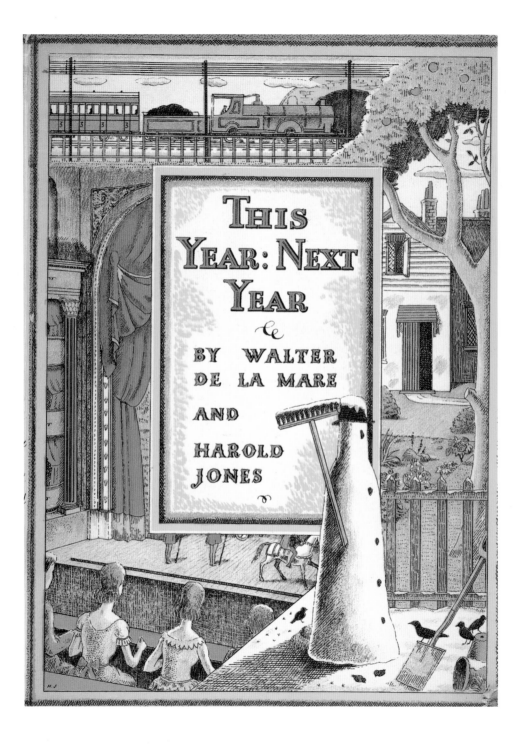

THIS YEAR: NEXT YEAR

BY WALTER DE LA MARE

AND

HAROLD JONES

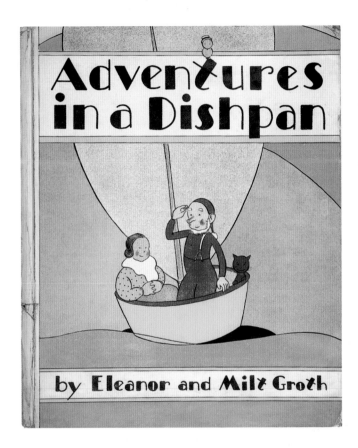

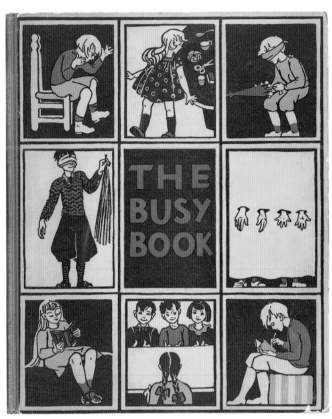

91A 91B

90 **This Year: Next Year** *Henry Holt & Co., New York. 1937. Design & Illustration: Harold Jones* This cover wonderfully represents the rich variety of changes and events contained in a single year, without appearing too chaotic or crowded. 91A **Adventures in a Dishpan** *Grosset & Dunlap, New York. 1936. Design & Illustration: Milt Groth*
91B **The Busy Book** *Doubleday, Doran & Co., New York. 1931* Title and image are well integrated on this ordered and informative cover.

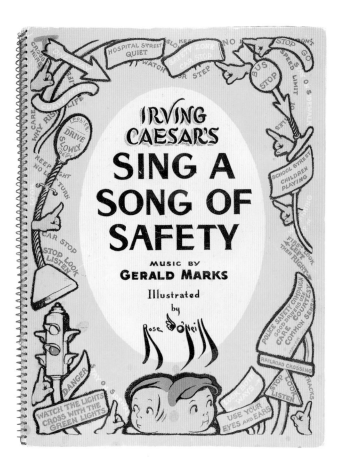

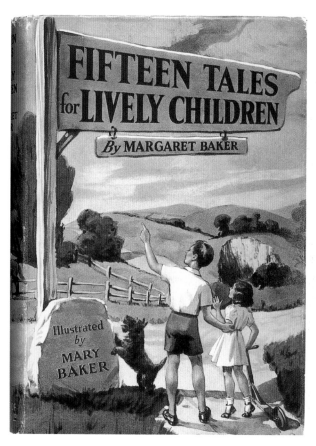

92A **Irving Caesar's Sing a Song of Safety** *Irving Caesar, New York. 1937. Illustration: Rose O'Neill* 92B **Fifteen Tales for Lively Children** *University of London Press, London. 1938. Illustration: Mary Baker* The child points us to the sign, and the sign points us to where we may open the book. 93A **Gladys Peto's Told in the Gloaming** *John F. Shaw & Co., London. 1932. Illustration: Gladys Peto* Gladys Peto (1890–1977) wonderfully embodies the decorative spirit of the 1920s and 1930s. She was also a very successful dress designer. 93B **Bobby Bun and Bunty** *Ward, Lock & Co., London. c. 1930. Illustration: D. E. Brahame*

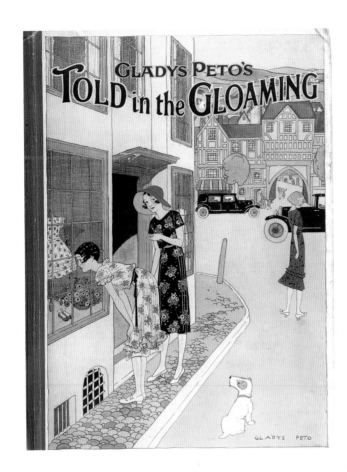

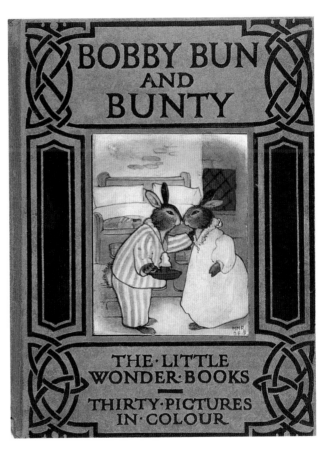

93A 93B

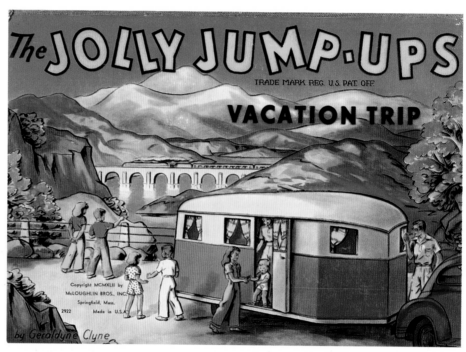

The
1940s

The first half of this decade was overshadowed by the Second World War. The human repercussions of this huge, terrible conflict were enormous. Here we are concerned with those aspects that affected design—book design in particular.

The war caused most people to live in a state of continual emergency. Almost every statement was simplified and emphasized. Everyday reality was grim, leading to an intense need to escape. Rationing of material goods led to a sense of privation. Design met these challenges by enlargement and visual emphasis. Roundness is everywhere in the 1940s. For example, *The Jolly Jump-Ups Vacation Trip* (page 94) is full of rounded forms, and the fat letters of the title are typical of type design of this period.

The second part of the 1940s was made buoyant by Allied victory in the war. This spirit affected the design of children's books more visibly in the following decade.

94 **The Jolly Jump-Ups Vacation Trip** *McLoughlin Bros., Springfield, Massachusetts. 1942. Illustration: Geraldyne Clyne*

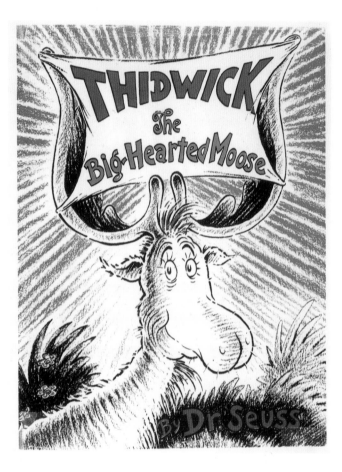

96 Thidwick the Big-Hearted Moose *Random House, New York. 1948. Design & Illustration: Dr. Seuss (Theodor Geisel)* Many of Theodor Geisel's (a.k.a. Dr. Seuss; 1904–91) cover characters look out at us. By making eye contact, Dr. Seuss's characters give us the sense that they know us and that we are part of the experience. **97 Babar's Picnic** *Random House, New York. 1949. Design & Illustration: Laurent de Brunhoff* Laurent de Brunhoff (b. 1925) continues the *Babar* books, which were begun by his father, Jean de Brunhoff (1899–1937), with *The Story of Babar* in 1933. The bold simplicity of this cover is just right for a children's book.

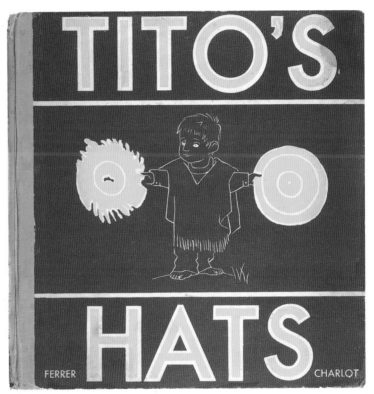

101A 101B

102A 102B

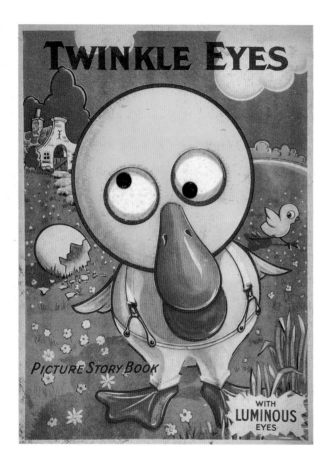

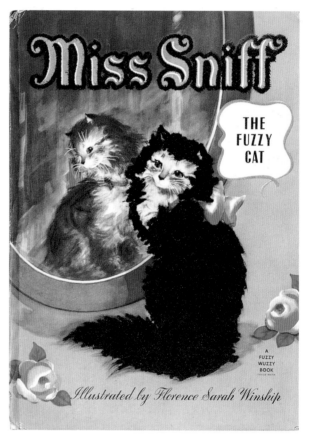

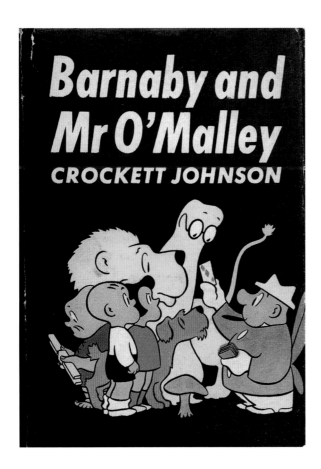

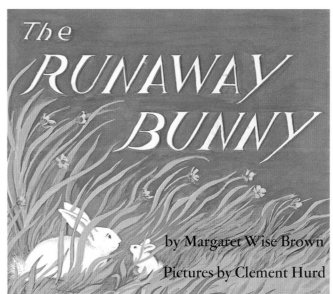

103A 103B

102A **Twinkle Eyes** *E. & M., London. 1940s. Illustration: Rie Reinderhoff* Not only do the eyes glow in the dark, but the pupils move freely as the book is tilted. 102B **Miss Sniff, the Fuzzy Cat** *Whitman Publishing Co., Racine, Wisconsin. 1945. Illustration: Florence Sarah Winship* This cover features another textured animal (also see *The Children's Companion*, page 61). 103A **Barnaby and Mr O'Malley** *Henry Holt & Co., New York. 1944. Illustration: Crockett Johnson* Crockett Johnson (1906–75) also created the *Harold and the Purple Crayon* series of picture books. 103B **The Runaway Bunny** *Harper, New York. 1942. Illustration: Clement Hurd* Clement Hurd (1908–88) and Margaret Wise Brown (1910–52) collaborated on a number of titles with felicitous results. This book and *Goodnight Moon* are probably the best known of their creations.

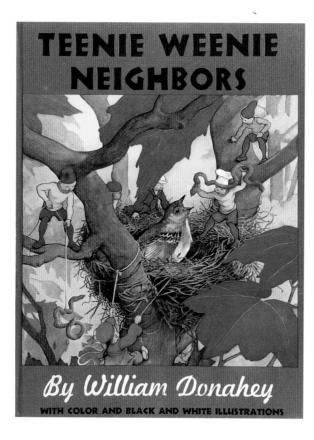

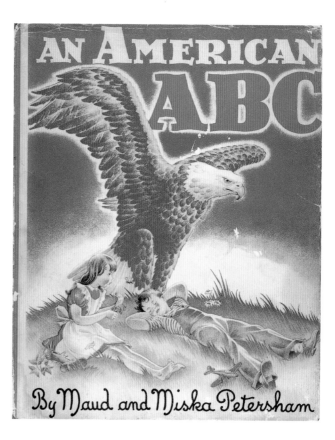

104A **Teenie Weenie Neighbors** *Whittlesey House, New York. 1945. Illustration: William Donahey* 104B **An American ABC** *Macmillan Co., New York. 1941. Design & Illustration: Maud and Miska Petersham* 105A **Mr. Bumps and His Monkey** *John C. Winston Co., Philadelphia. 1942. Illustration: Dorothy P. Lathrop* 105B **The Little Prince** *Reynal & Hitchcock, New York. 1943. Illustration: Antoine de Saint-Exupéry* Antoine de Saint-Exupéry (1900–1944) gives us the essence of *The Little Prince*—a stranger in an unfamiliar world—on the cover of this book.

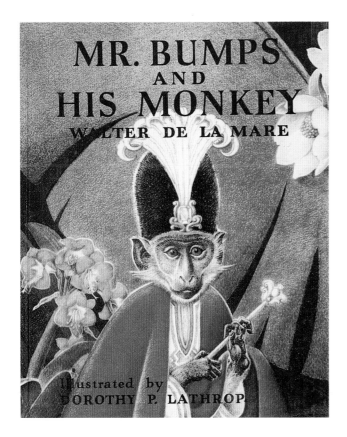

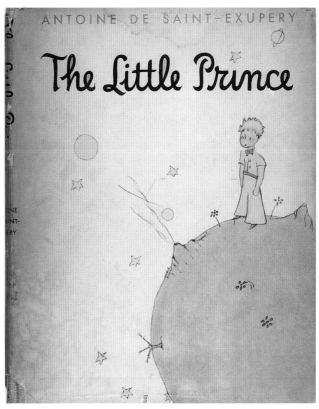

105A 105B

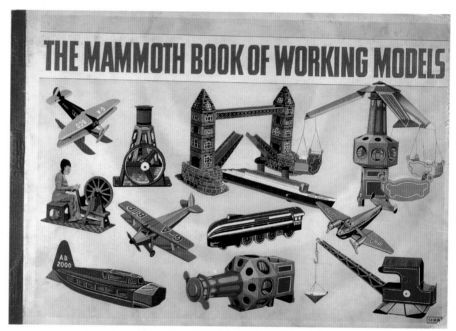

The
1950s

Finally, we have a decade in which the books consistently looked like products of their time. Wars act as walls separating one era from another, and the war just ended finally extinguished the lingering nostalgia for the manners and feelings of the late nineteenth century. As someone who has been very ill and regains health finds anew the richness of existence, so a nation after a victorious war feels a sense of boundless possibilities. Children's book publishers, in this mood, were willing to try almost any new idea, and they encouraged new authors, illustrators, and designers to manifest their ideas.

The 1950s was a golden age for magazines, and it was a rare home that did not have several magazines delivered weekly. Since magazine design is characterized by chaos insufficiently controlled, their ever-present example tended to adversely affect book design. This, coupled with postwar optimism and a sense of abundance, frequently resulted in too-crowded pages and covers.

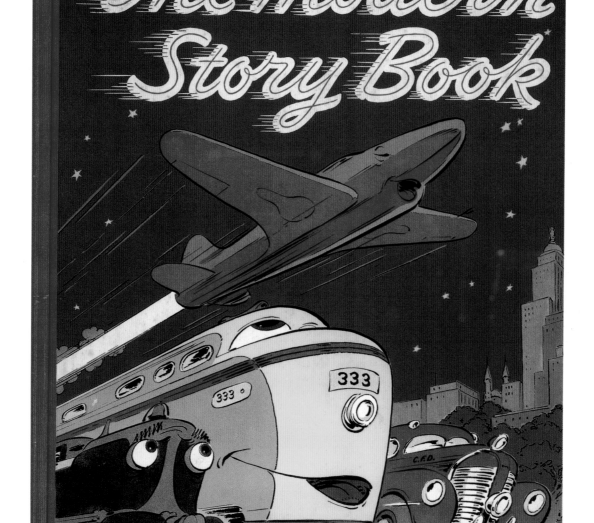

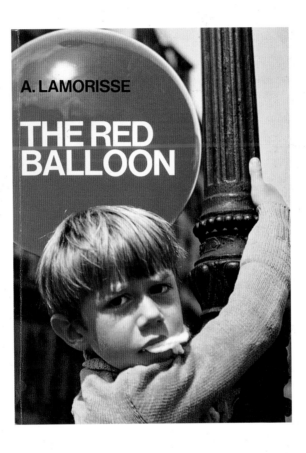

109

108 **The Modern Story Book** *Rand McNally & Co., New York. 1950. Illustration: Paul Pinson* The "modern" world is careening full speed ahead. The happy faces on the machines show us that their intentions are good. 109 **The Red Balloon** *Doubleday & Co., New York. 1956. Illustration: Albert Lamorisse* The photographic cover is in short supply in the world of children's books. Until recently they were infrequently attempted, and they were successful even less often. This book was based on the popular motion picture.

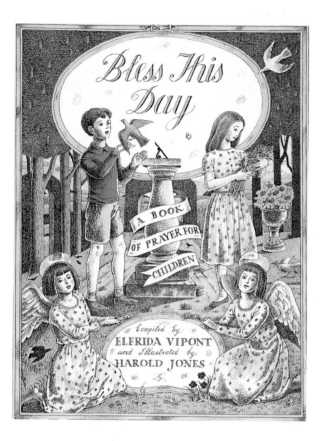

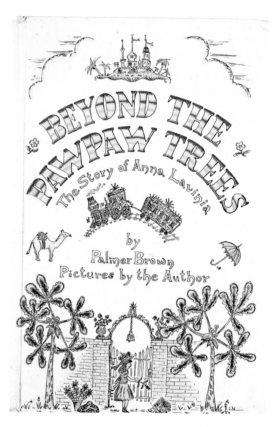

110A 110B

110A **Bless This Day: A Book of Prayer for Children** *Collins, London. 1958. Design & Illustration: Harold Jones* This is a design of formal and balanced beauty, almost like a dedicatory plaque. 110B **Beyond the Pawpaw Trees: The Story of Anna Lavinia** *Harper & Row, New York. 1954. Design & Illustration: Palmer Brown* This is a friendly handmade cover for a cozy heartfelt story. 111 **The Rabbits' Wedding** *Harper & Row, New York. 1958. Illustration: Garth Williams* The marriage of a black-furred and a white-furred rabbit caused some controversy when this book was published.

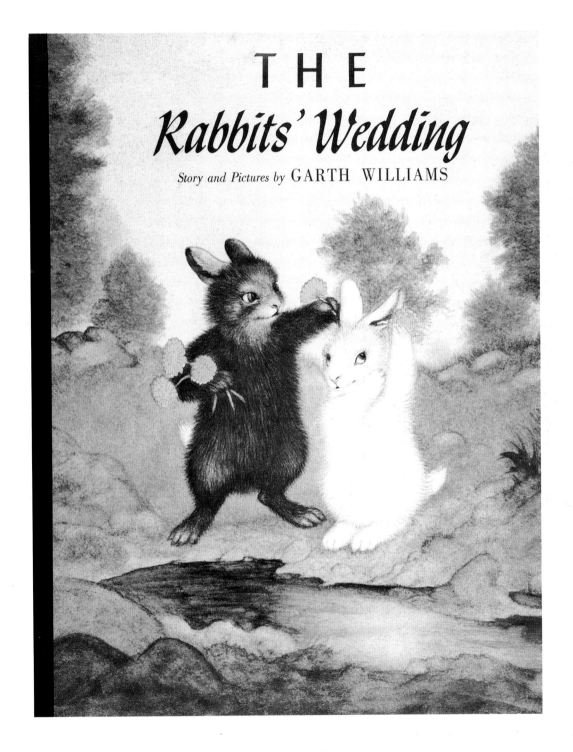

THE
Rabbits' Wedding
Story and Pictures by GARTH WILLIAMS

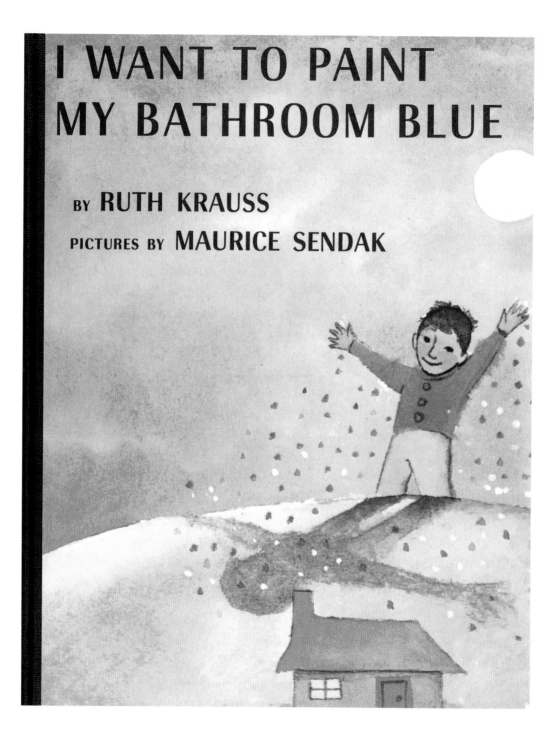

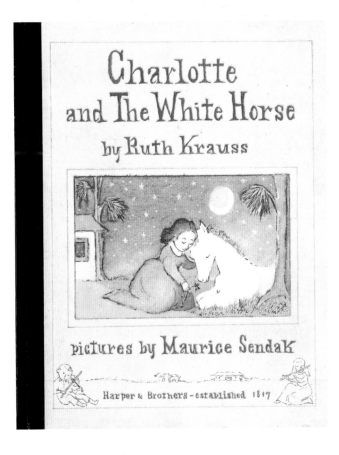

112 **I Want to Paint My Bathroom Blue** *Harper & Row, New York. 1956. Illustration: Maurice Sendak* 113 **Charlotte and The White Horse** *Harper & Bros., New York. 1955. Design & Illustration: Maurice Sendak* There are those who prefer the earlier, sweeter Sendak.

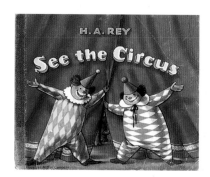

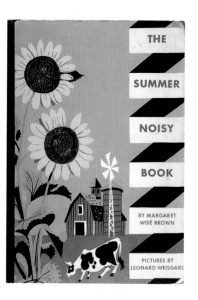

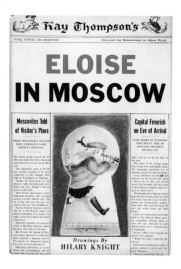

114A 114B 114C

114A **See the Circus** *Houghton Mifflin Co., New York. 1956. Design & Illustration: H. A. Rey* The clowns part the curtain to persuade you to enter the book. 114B **The Summer Noisy Book** *Harper & Bros., New York. 1951. Illustration: Leonard Weisgard* 114C **Eloise in Moscow** *Simon & Schuster, New York. 1959. Illustration: Hilary Knight* An ersatz newspaper front page is an apt vehicle for this book cover, and the currency of the subject lends itself well to this format. 115 **If I Ran the Zoo** *Random House, New York. 1950. Illustration: Dr. Seuss (Theodor Geisel)* Another of Dr. Seuss's compelling characters looks at us boldly, if a little nuttily.

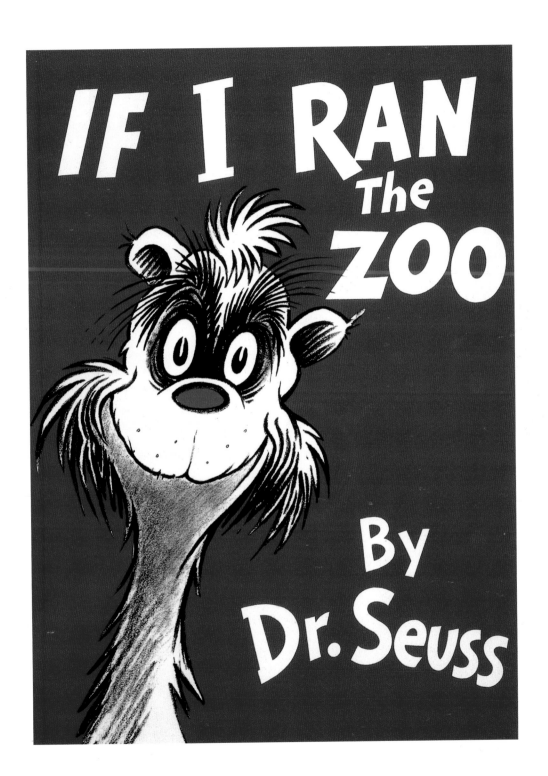

116A 116B

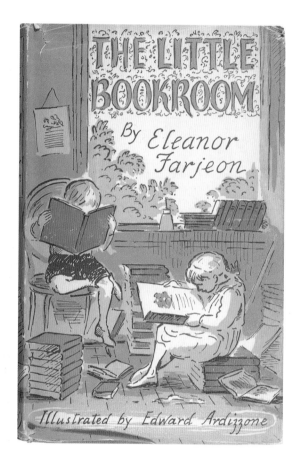

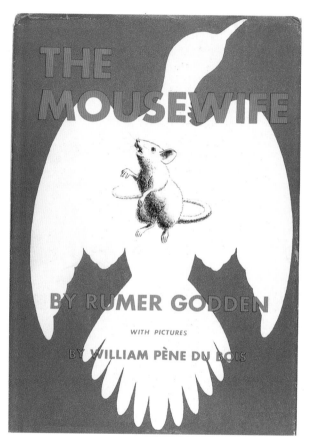

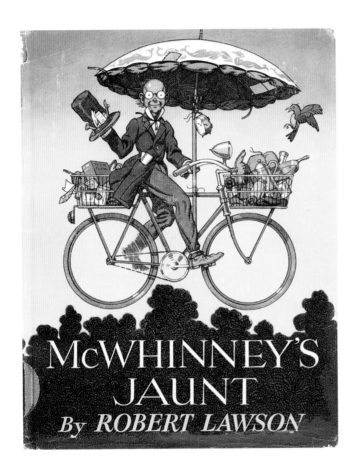

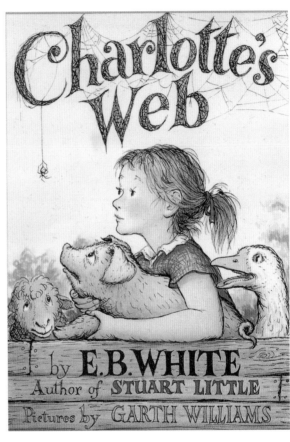

117A 117B

116A **The Little Bookroom** *Oxford University Press, London. 1955. Design & Illustration: Edward Ardizzone* 116B **The Mousewife** *Viking Press, New York. 1951.*
Illustration: William Pène du Bois The spirit of the book is nicely captured on this cover—the timid mouse struggling to understand the world and the bird's place in it.
117A **McWhinney's Jaunt** *Viking Press, New York. 1951. Illustration: Robert Lawson* Robert Lawson (1892–1957) piques our interest in the "jaunt" by showing us a variety
of curiosities, oddities, and downright improbabilities, which beg further investigation. 117B **Charlotte's Web** *Harper & Bros., New York. 1952. Illustration: Garth Williams*
Author E. B. White wrote approvingly of this cover: "The proof of the jacket is very gay and I think all five of the characters are beguiling."

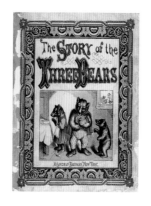
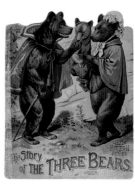

Multiple
covers
for the same theme

The comparisons offered here make it clear how much the artist and designer determine the impact of a book's cover and how little the book's content dictates its appearance at times.

The *Sleeping Beauty* covers, for example, are so different in tone that they hardly seem to pertain to the same story. The right-hand *Hansel and Gretel* (page 122) makes the children seem totally deceived and intrigued, whereas the left one's children are in a state of apprehension. The *Little Red Riding Hood* covers vary from the humorous to the sinister. *Alice in Wonderland* is the best demonstration of the ways in which the cover represents the nature of the story. The Dean Gold Medal book makes it an eccentrically humorous adventure; Bessie Pease shows us a tender, childish dream; the Bodley Head edition makes it a magical, and powerful book; Gertrude Kay's version seems to be a standard format cover into which an illustration has been dropped; and Mabel Attwell lettered and arranged her cover so as to take us immediately into her version of the story.

118A **The Story of the Three Bears** *McLoughlin Bros., New York. 1880s* 118B **The Story of the Three Bears** *McLoughlin Bros., New York. 1892* 118C **The Three Bears** *McLoughlin Bros., New York. 1888. Design & Illustration: R. André* Other than the three bears, R. André's cover bears no relation to the story inside; one wonders what prompted this peculiar interpretation.

120A 120B 120C

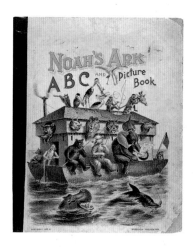

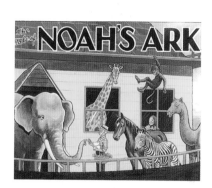

120A Noah's Ark ABC and Picture Book *McLoughlin Bros., New York. 1905. Illustration: Fredrika Grosvenor* **120B The Noah's Ark** *Ernest Nister, London. 1880s. Illustration: G. H. Thompson* **120C The Tale of Noah's Ark** *Len Art Series, London. 1940s* Children like animals, so naturally they like Noah's ark, where all the animals are assembled together. In these books two of the arks are peopled by friendly animals, the other makes us want to venture inside. **121A The Sleeping Beauty** *Blackie & Son, London. 1910s. Illustration: John Hassall* **121B Sleeping Beauty** *Samuel Gabriel Sons & Co., New York. 1940s. Illustration: R. A. Burley* **121C Sleeping Beauty, Pantomime Toy Book** *McLoughlin Bros., New York. 1890s* **121D The Sleeping Beauty** *Ernest Nister, London. 1898*

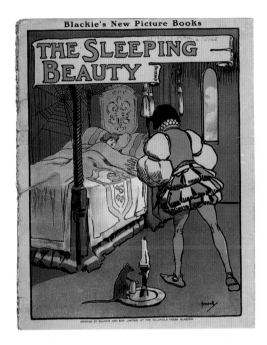

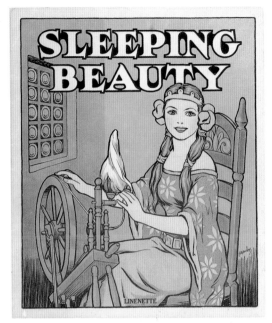

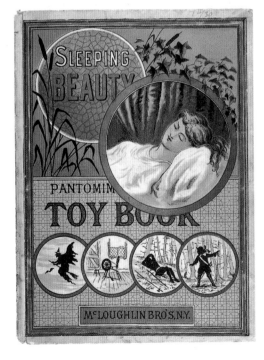

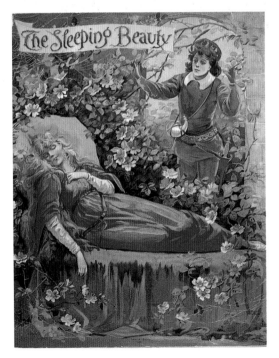

121A 121B
121C 121D

122A 122B

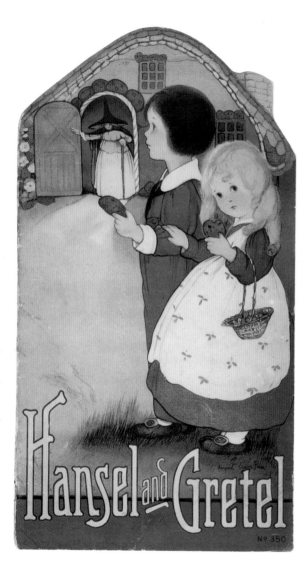

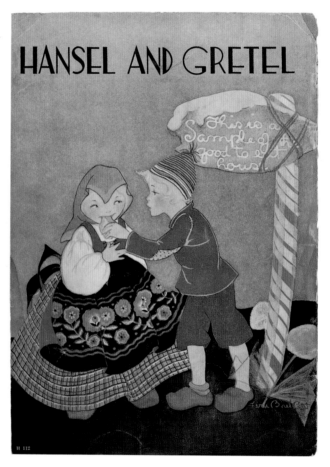

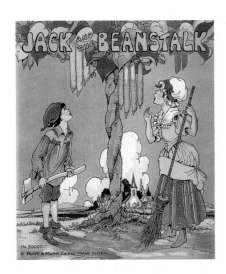

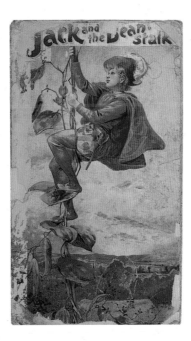

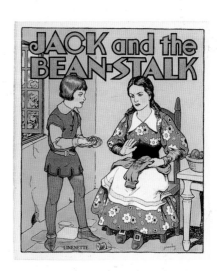

123A 123B 123C

122A **Hansel and Gretel** *Stecher Lith. Co., Rochester, New York. 1916. Design & Illustration: Margaret Evans Price* In this cover Gretel looks at us pleadingly, hungrily, as her and Hansel's troubles are just about to deepen. We want to help—and read the book to make sure that everything turns out all right. 122B **Hansel and Gretel** *Harter Publishing Co., Cleveland. 1932. Illustration: Fern Bisel Peat* 123A **Jack and the Beanstalk** *Platt & Munk Co., New York. 1934. Design & Illustration: Eulalie* 123B **Jack and the Bean-stalk** *Ernest Nister, London. 1910s* 123C **Jack and the Bean-stalk** *Samuel Gabriel Sons & Co., New York. 1940s. Illustration: R. A. Burley* On the Eulalie cover, Jack and his mother stare up the beanstalk and, conveniently, at the title as well.

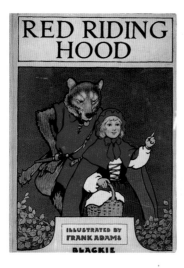

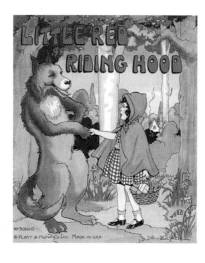

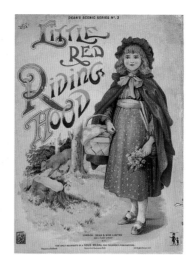

124A 124B 124C
124D 124E 124F

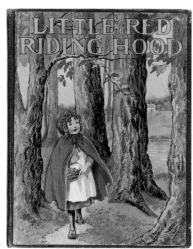

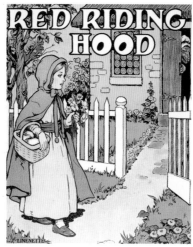

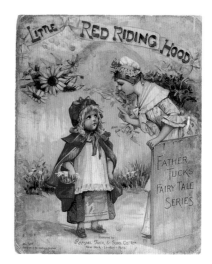

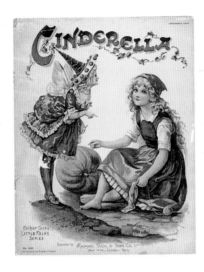

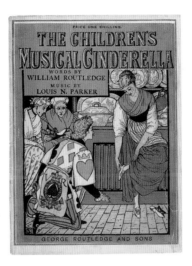

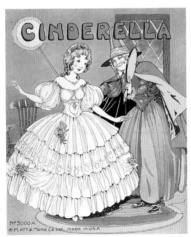

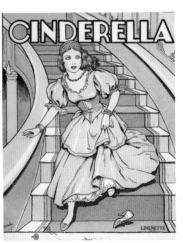

125A 125B
125C 125D

124A **Red Riding Hood** *Blackie & Son, London. 1920s. Design & Illustration: Frank Adams* 124B **Little Red Riding Hood** *Platt & Munk Co., New York. 1934. Design & Illustration: Eulalie* 124C **Little Red Riding Hood** *Dean & Son, London. 1900s* 124D **Little Red Riding Hood** *M. A. Donohue & Co., Chicago. 1921* 124E **Red Riding Hood** *Samuel Gabriel Sons & Co., New York. 1940s. Illustration: R. A. Burley* 124F **Little Red Riding Hood** *Raphael Tuck & Sons, New York. 1910s* 125A **Cinderella** *Raphael Tuck & Sons, New York. 1930s* This very peculiar fairy catches our attention on the Cinderella cover by Raphael Tuck & Sons. 125B **The Children's Musical Cinderella** *George Routledge & Sons, London. 1879. Illustration: Walter Crane* 125C **Cinderella** *Platt & Munk Co., New York. 1934. Design & Illustration: Eulalie* 125D **Cinderella** *Samuel Gabriel Sons & Co., New York. 1940s. Illustration: R. A. Burley*

126A 126B 126C

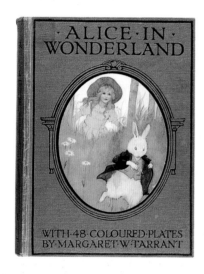
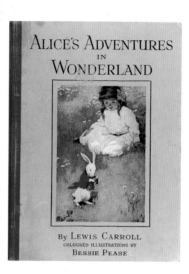
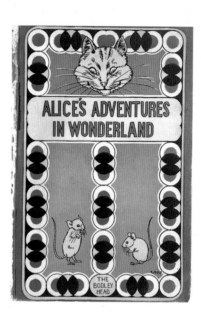

126A **Alice in Wonderland** *Ward, Lock & Co., London. 1916. Illustration: Margaret W. Tarrant* 126B **Alice's Adventures in Wonderland** *J. Coker & Co., London. 1907.*
Illustration: Bessie Pease (Bessie Pease Guttmann) 126C **Alice's Adventures in Wonderland** *John Lane, The Bodley Head, London. 1907. Design & Illustration: W. H. Walker*
127A **Alice's Adventures in Wonderland** *J. B. Lippincott Co., Philadelphia. 1923. Illustration: Gertrude A. Kay* 127B **Alice in Wonderland** *Raphael Tuck & Sons, London.*
1910. Design & Illustration: Mabel Lucie Attwell

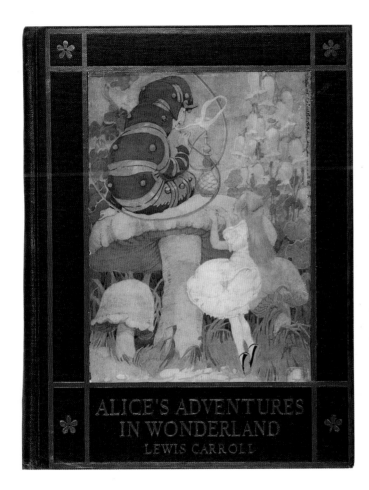

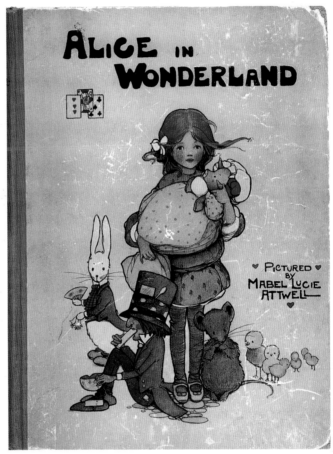

127A 127B

128A 128B
128C 128D

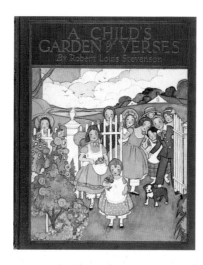
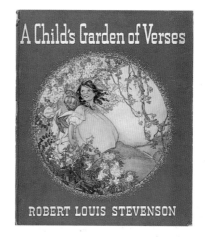
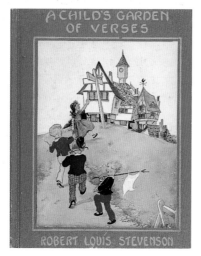

129A 129B

128A **A Child's Garden of Verses** *J. H. Sears & Co., New York. 1926. Illustration: Eva Noé* 128B **A Child's Garden of Verses** *Rand McNally & Co., Chicago. 1940. Illustration: Ruth Mary Hallock* 128C **A Child's Garden of Verses** *Platt & Munk Co., New York. 1929. Illustration: Eulalie* 128D **A Child's Garden of Verses** *Merrill Publishing Co., Chicago. 1939. Illustration: George Trimmer* 129A **A Child's Garden of Verses** *Saalfield Publishing Co., New York. 1930. Illustration: Clara M. Burd* 129B **A Child's Garden of Verses** *Whitman Publishing Co., Racine, Wisconsin. 1932. Illustration: Juanita C. Bennett* Inasmuch as Stevenson's poems treat almost the whole range of childhood experience, cover designers have an almost unlimited freedom of choice as to mood or subject.

130A 130B 130C

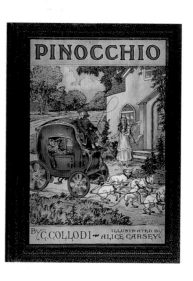

130A **Pinocchio: The Adventures of a Puppet** *McLoughlin Bros., Springfield, Massachusetts. 1938. Illustration: H. G. Nicholas* The very popular "Little Big" series, produced by McLoughlin Bros., emphasizes Pinocchio's unfettered mischief. **130B** **Adventures of Pinocchio** *Macmillan Co., New York. 1926. Illustration: Attilio Mussino* **130C** **Pinocchio** *Whitman Publishing Co., Racine, Wisconsin. 1916. Illustration: Alice Carsey* **131A** **Pinocchio: The Adventures of a Puppet** *Harper & Bros., New York. 1925. Illustration: Maurice Day* **131B** **The Adventures of Pinocchio** *Grosset & Dunlap, New York. 1955. Illustration: Maraja* **131C** **The Adventures of Pinocchio** *Sully & Kleintech, New York. 1910s* **131D** **Pinocchio: Tale of a Puppet** *Whitman Publishing Co., Racine, Wisconsin. 1916*

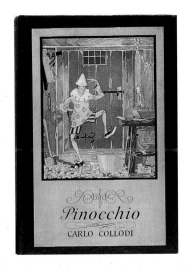

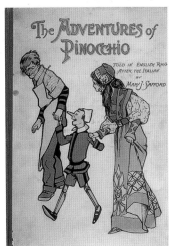

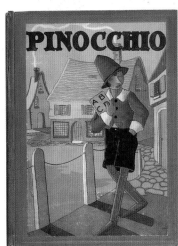

131A 131B
131C 131D

Mother
goose
1860–1950

Since the late seventeenth century an elderly storyteller known as Mother Goose has been the mythic keeper of children's rhymes. Hers is a comfortable image, and we are happy to leave to her the keeping of this precious legacy.

Each era puts its imprint on this collection of nursery rhymes, even though the rhymes themselves remain largely unchanged. Further, each artist and designer sees them from their unique vantage.

The character of Mother Goose is ever changing. The earlier ones tend to be crones with pronounced chins, as are the ones from the 1870s and 1890s. The 1888 Mother Goose is, oddly, a young woman. The 1911 lady is motherly, and the one from 1929 has power and magic.

Many cover designers from recent decades choose one of the rhymes as their subject, which gives them an enormous range of choices, but it loses the opportunity for a central and really imaginative statement.

132A **Nursery Rhymes** *Milner & Sowerby, Halifax. 1863* 132B **The Original Mother Goose Melodies** *Lee & Shepard Publishers, Boston. 1878. Illustration: J. F. Goodridge*

134

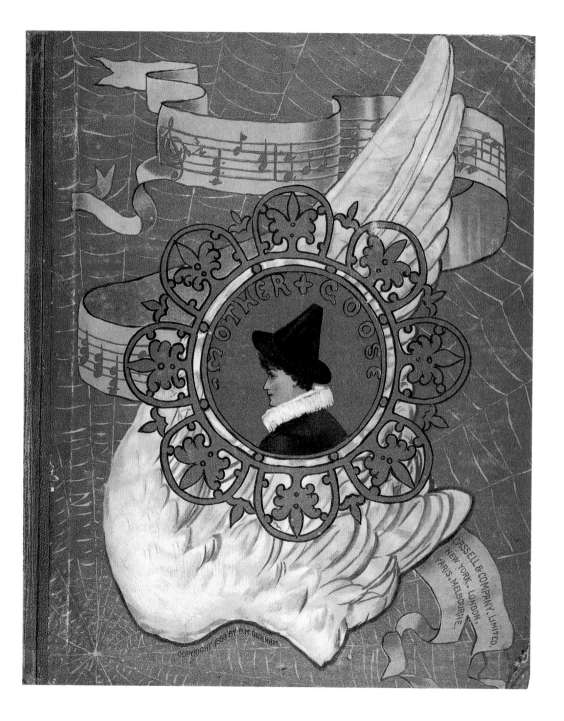

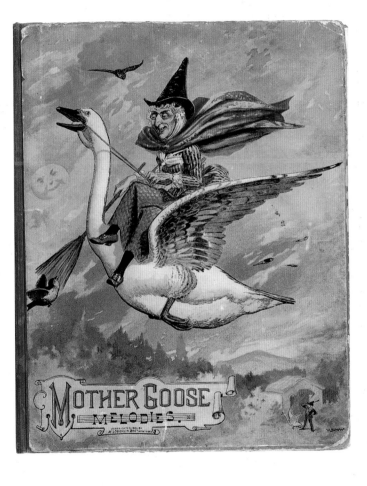

134 **Mother Goose** *Cassell & Co., New York. 1888. Design & Illustration: J. L. Webb* 135 **Mother Goose Melodies** *McLoughlin Bros., New York. 1894*

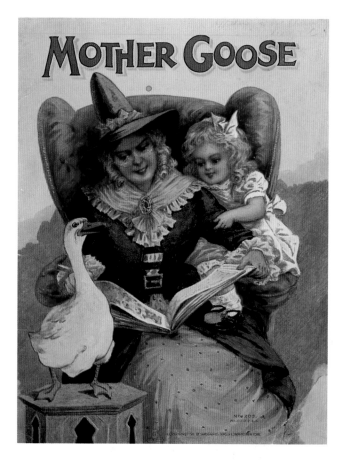

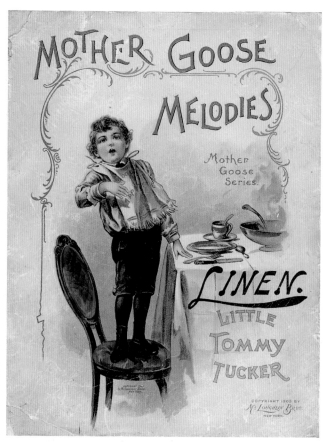

136A 136B

136A **Mother Goose** *Samuel Gabriel Sons & Co., New York. 1911. Illustration: Mary LaFetra Russell* 136B **Mother Goose Melodies** *McLoughlin Bros., New York. 1903*
In this McLoughlin Bros. edition, one hopes they will be able to sing as expressively as Tommy Tucker, but there are, inexplicably, no "melodies" in this book. 137A **Mother Goose: Her Own Book** *Reilly & Lee Co., Chicago. 1932. Illustration: Mary Royt* 137B **Mother Goose Nursery Tales** *J. Coker & Co., London. 1929. Illustration: Margaret W. Tarrant* 137C **The Big Book of Mother Goose** *John Martin's House, Kenosha, Wisconsin. 1946* 137D **Mother Goose Rhymes** *Platt & Munk Co., New York. 1953. Illustration: Eulalie*

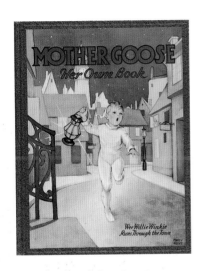

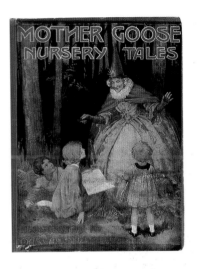

137A 137B

137C 137D

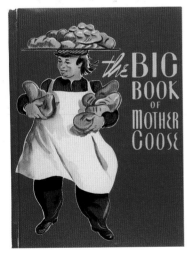

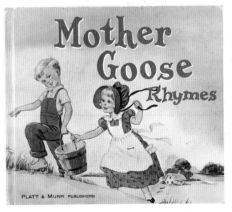

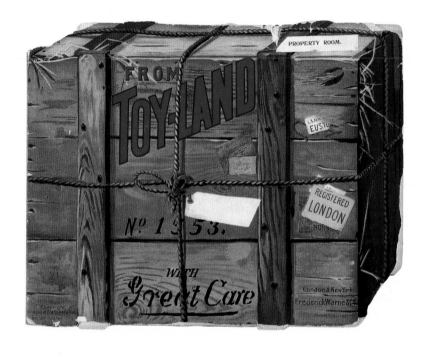

Shaped
books

Shaped books demonstrate that the progress from the image of an object to the object itself can be gradual. First, we have the convincingness of the image; the more realistic it is, the closer we feel to the thing itself. A beautifully rendered glass of lemonade, with moisture beading on the glass, does inspire thirst. Size is another factor, as we are more convinced by a reproduction that approximates the size of the original. Finally, and perhaps most important, shape is a factor. A book shaped like a bluebird makes us feel as if we can pick up and hold the bird itself.

Children, having less experience, are less firmly anchored in everyday reality, and so can be even more readily confused by the distinction between picture and thing. Thus, shaped books have, for them, special power.

The first shaped books I know of are cross-shaped devotional books from the Middle Ages. With examples from the sixteenth century, the earliest shaped books for children were horn books, their shape serving a practical purpose, so the child could grip the handle as he or she worked on the material above it.

138 **From Toy-land** *Frederick Warne & Co., London. 1880s.* What child could resist a package from "Toy-land"? The reality and detail the artist adds to the crate are part of what makes this cover stand out.

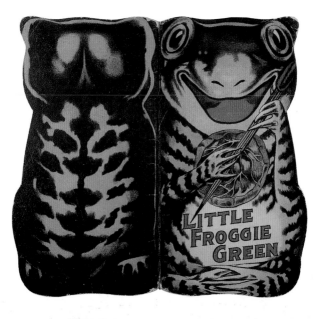

140A
140B

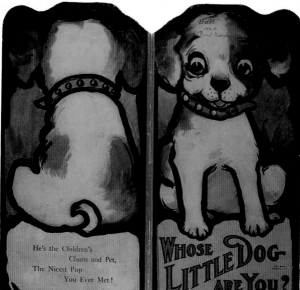

140A **Little Froggie Green** *Saalfield Publishing Co., New York. 1917* 140B **Whose Little Dog Are You?** *Samuel Gabriel Sons & Co., New York. 1913* 141A **Ball Paint Book** *n.p., n.p. 1911* 141B **Mother Goose Painting Book** *Platt & Peck Co., New York. 1913. Design & Illustration: Elizabeth Colborne*

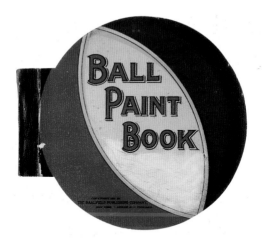

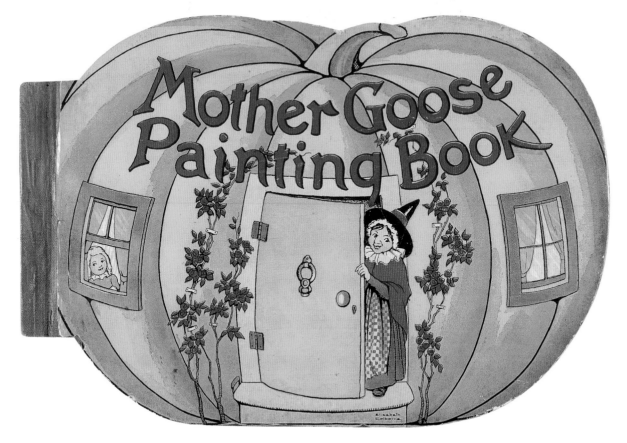

141A
141B

142A 142B

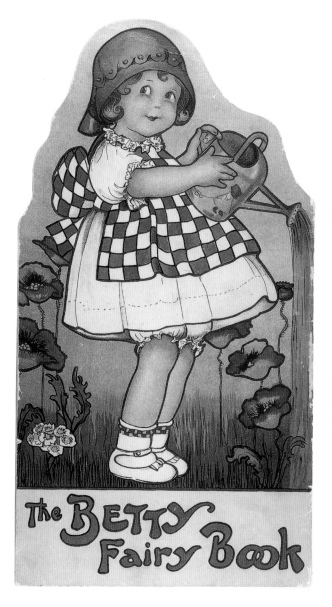

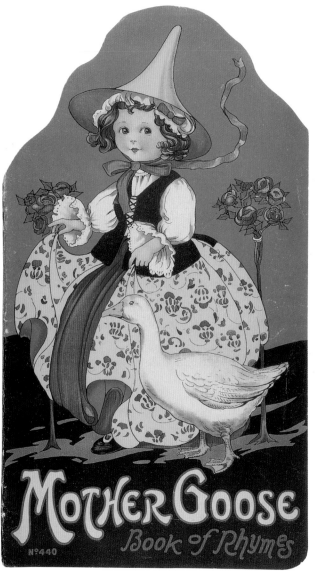

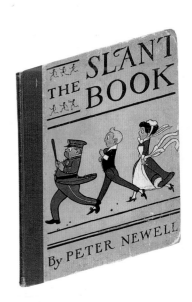

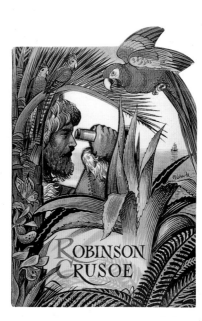

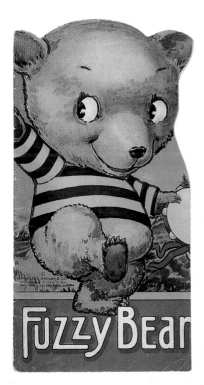

143A 143B 143C

142A **The Betty Fairy Book** *Stecher Lith. Co., Rochester, New York. 1915. Design & Illustration: Margaret Evans Price* 142B **Mother Goose Book of Rhymes** *Stecher Lith. Co., Rochester, New York. 1917. Design & Illustration: Margaret Evans Price* 143A **The Slant Book** *Harper & Bros., New York. 1910. Design & Illustration: Peter Newell* The downhill slant of this remarkable work is used to show the downhill journey of a baby in a runaway baby carriage. 143B **Robinson Crusoe** *ARTIA Prag, Prague. 1957. Design & Illustration: Vojtěch Kubasta* 143C **Fuzzy Bear** *Charles E. Graham & Co., New York. 1930s*

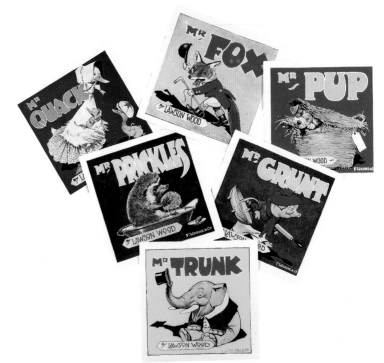

Series
books

Books that turn into series tend to have a bad reputation with scholars and librarians, who perceive them as being "churned out," as if in a factory, with little regard for quality. Histories of children's literature pay scant attention to Nancy Drew, the Oz stories, or most children's books that evolve a set of characters through many volumes. This is ungrounded snobbery, for there is no inherent reason that inspiration cannot flourish as well under this circumstance as any other. For a cover designer, there is much to recommend books in a series. It is a challenge similar to the one a composer faces when making variations on a theme, and like a work of music, the growing set of volumes, seen together, has a power greater than its parts.

144 **The Hamper of "Mr." Books** *Frederick Warne & Co., London. 1916. Illustration: Lawson Wood*

146 **The Secret of the Old Clock** *Grosset & Dunlap, New York. 1959. Illustration: Polly Bolian* 147 **The Ringmaster's Secret** *Grosset & Dunlap, New York. 1959. Illustration: Polly Bolian*

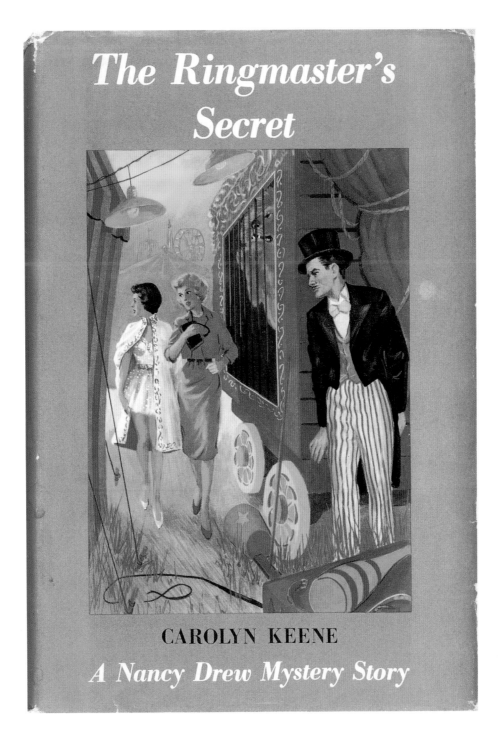

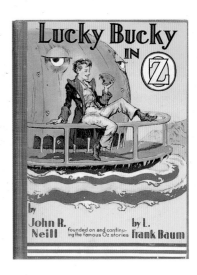

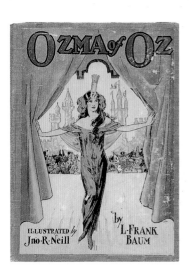

148A 148B 148C

148A **Lucky Bucky in Oz** *Reilly & Lee Co., Chicago. 1942. Design & Illustration: John R. Neill* 148B **The Emerald City of Oz** *Reilly & Lee Co., Chicago. 1910. Design & Illustration: Jno (John) R. Neill* 148C **Ozma of Oz** *Reilly & Lee Co., Chicago. 1907. Design & Illustration: Jno (John) R. Neill* 149A **Jack Pumpkinhead of Oz** *Reilly & Lee Co., Chicago. 1929. Design & Illustration: Jno (John) R. Neill* 149B **The Wonder City of Oz** *Reilly & Lee Co., Chicago. 1940. Design & Illustration: John R. Neill* Using a few thematic devices across all of the covers, namely the Oz logo and the consistent placement of typographical information, the series holds together over the decades while allowing each title to have its own personality.

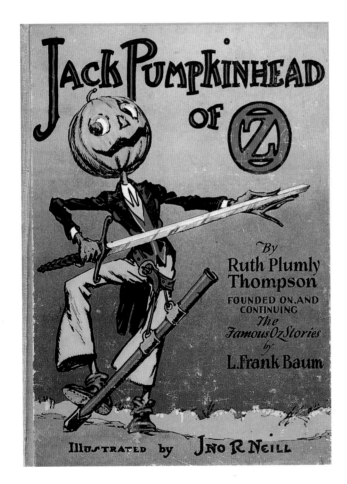

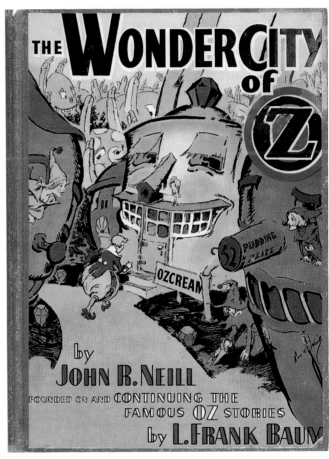

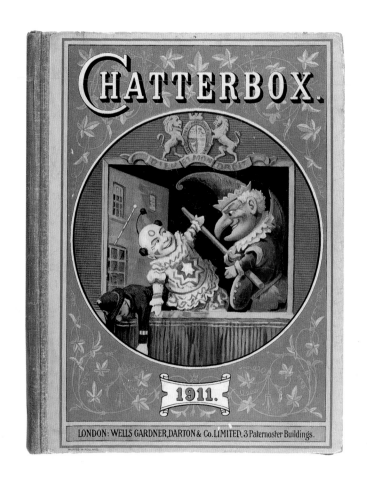

Annuals

Annuals are collections of original stories, poems, articles, and pictures assembled to entertain young readers. In England (ever since the 1890s) there have been hundreds of different annuals, and it used to be the rare child who did not receive an annual on Christmas Day. Because of their success, many superb authors and illustrators have been commissioned to work for them. The United States has never taken to annuals as England has; *Chatterbox* was the sole success.

The covers of annuals are frequently superb because everyone understands that a gift must look impressive and stand proudly beside dolls, sleds, and toy soldiers. They tend to have a basic stylistic arrangement, each year playing variations on this foundation. This also leads to excellence because any act repeated tends to be more effectively performed.

Annuals are such a rich field that they deserve a well-illustrated, book-length appreciation.

152

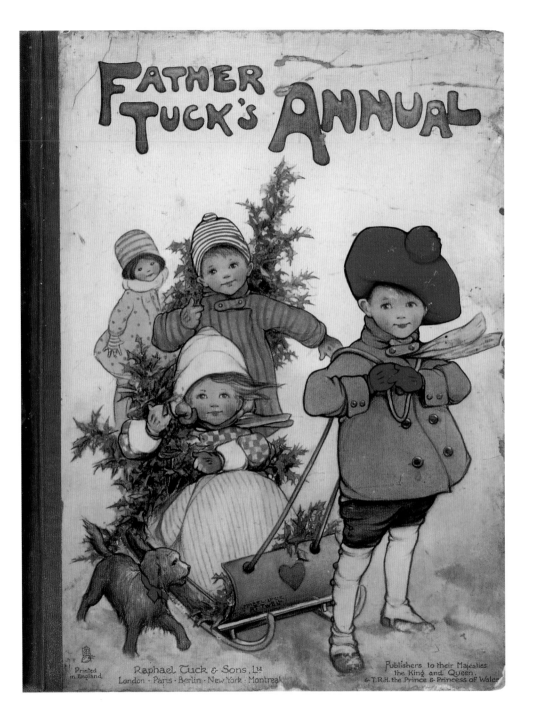

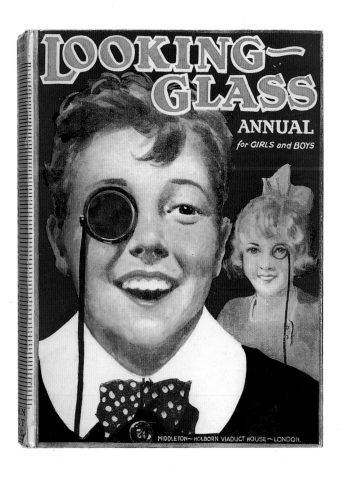

153

152 **Father Tuck's Annual** *Raphael Tuck & Sons, London. c. 1909. Illustration: Mabel Lucie Attwell* 153 **Looking-Glass Annual for Girls and Boys** *Middleton Publications, London. 1920s* The monocle is an actual glass mirror set into this book's cover.

154A 154B

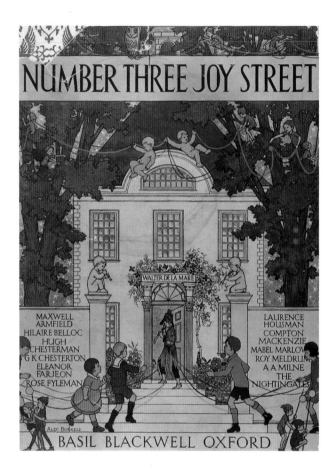

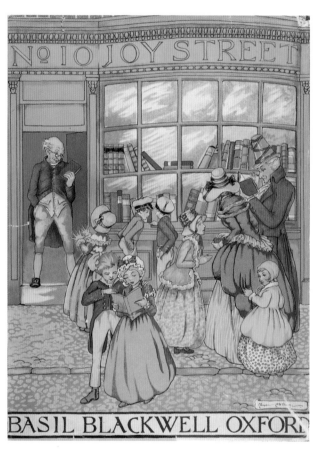

154A **Number Three Joy Street** *Basil Blackwell, Oxford. 1920s. Illustration: Alec Buckels* Each year this annual's cover featured a different building along the mythical "Joy Street." Inside one finds a rich collection of poetry, prose, and pictures, different from last year's offerings but in the same pleasurable vein. An almost perfect device.

154B **Number Ten Joy Street** *Basil Blackwell, Oxford. 1932. Illustration: Marion Allen* 155 **Partridge's Children's Annual** *S. W. Partridge & Co., London. c. 1912*

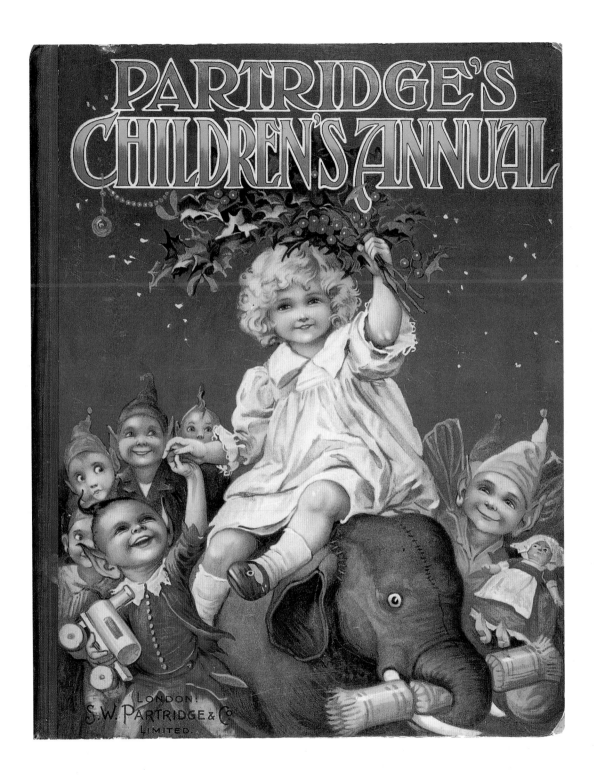

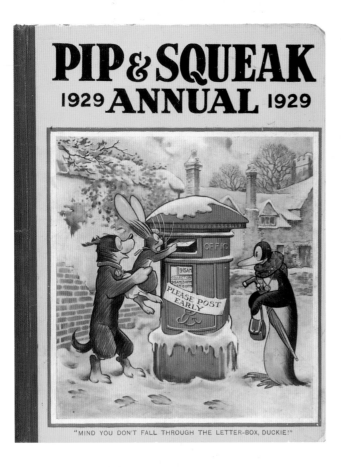

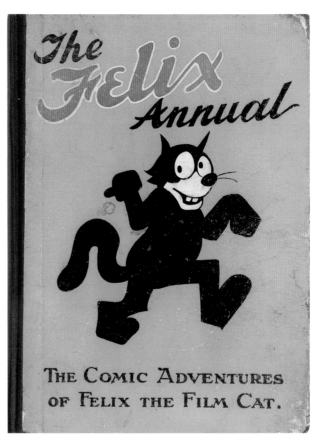

156A **Pip & Squeak Annual 1929** *Daily Mirror, London. 1929* 156B **The Felix Annual: The Comic Adventures of Felix the Film Cat** *E. Hulton & Co., London.*
c. 1920. Illustration: Pat Sullivan Many popular folk characters become the organizing center of a series of annuals. 157 **The Happy Annual** *E. P. Dutton & Co., New*
York. c. 1913. Illustration: Cecil Aldin

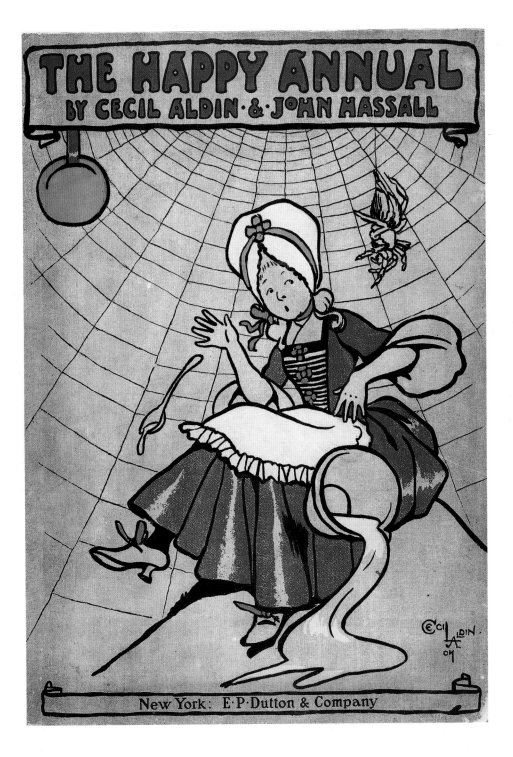

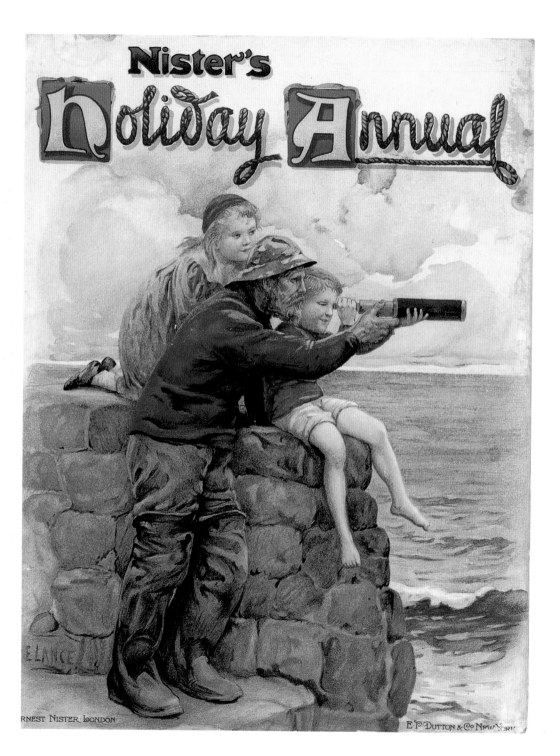

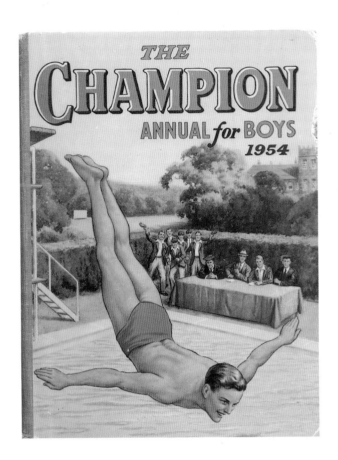

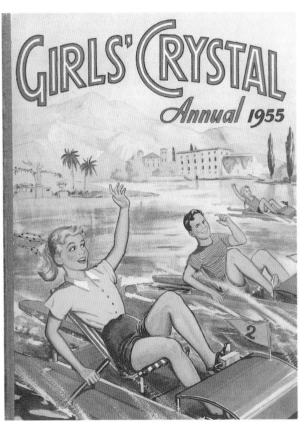

159A 159B

158 **Nister's Holiday Annual** *Ernest Nister, London. 1907. Illustration: E. Lance* The rope title on this seafaring-themed cover is appropriate and attractive.

159A **The Champion Annual for Boys 1954** *Fleetway House, London. 1954* 159B **Girls' Crystal Annual 1955** *Fleetway House, London. 1955*

Some great cover artists

The few pages allotted here cannot begin to cover the breadth of talent at work in children's book cover design and illustration (a fact every picture in this book lays testament to). I have here attempted to marry highly personal favorites with the desire to show a range of periods and approaches. Thus it should surprise no one that I have left out many great illustrators. It should also be noted that I have attempted to shed light in many different directions, rather than focusing solely on the most well known names (as I have in the whole book).

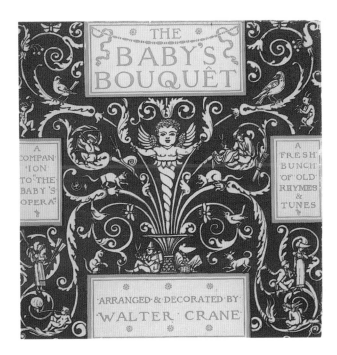 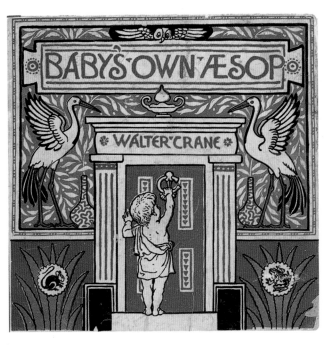

161A 161B

Walter Crane (1845–1915) was an English artist whose talents and energy made him a giant in many arenas. He painted in oils; designed carpets, ceramics, posters, calendars, and gardens; was a socialist leader; wrote books on design; and was one of the great illustrators of his time. • His children's books were strongly influenced by his study of the Japanese woodblock artists. He adapted their use of broad areas of color to the printing techniques of his day. He was one of the first illustrators to recognize that commercial color printing held artistic possibilities of its own. • Crane's covers are clearly the work of a master designer and calligrapher, and they excel both through his illustrative abilities and his grasp of balance and symmetry.

161A **The Baby's Bouquet** *Frederick Warne & Co., London. 1879. Design & Illustration: Walter Crane* 161B **Baby's Own Aesop** *Frederick Warne & Co., London. 1886. Design & Illustration: Walter Crane* Tiles were manufactured from the designs in this book, and other Crane books, by Maw and Co., and the books seem like tiles in their square formality.

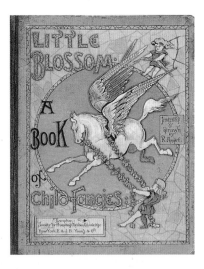

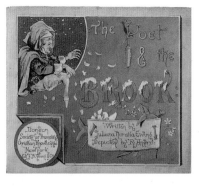

162A 162B
162C 162D

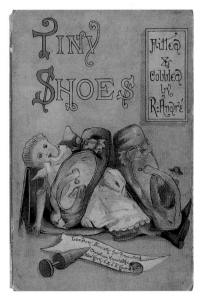

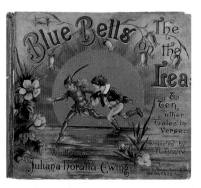

R. André was a British illustrator who published books between 1876 and 1907. We are not sure whether André was a man or a woman. What we do know is that his or her books are, inside and out, gloriously original and marvelously designed. The lettering on these covers has, in each case, been created for that purpose alone. Another characteristic of André is the ability to fill a page with images, words, and devices, and yet place them so harmoniously that the covers seem neither overfilled nor chaotic.

162A **Little Blossom: A Book of Child Fancies** *Society for Promoting Christian Knowledge, London. 1880s. Design & Illustration: R. André* 162B **The Poet & the Brook** *Society for Promoting Christian Knowledge, London. 1890s. Design & Illustration: R. André* 162C **Tiny Shoes** *Society for Promoting Christian Knowledge, London. 1890s. Design & Illustration: R. André* 162D **The Blue Bells on the Lea & Ten other Tales in Verse** *Society for Promoting Christian Knowledge, London. 1884. Design & Illustration: R. André*

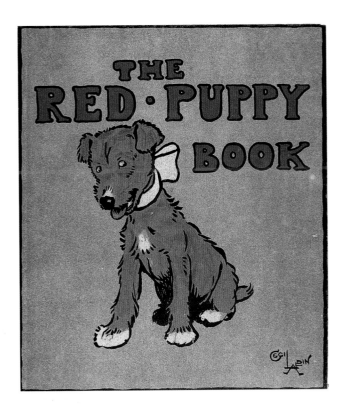

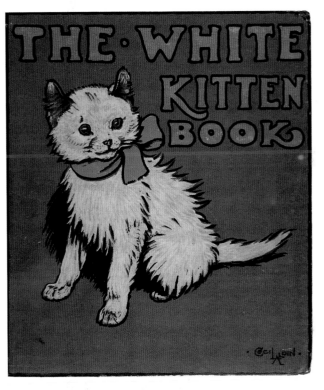

163A 163B

Cecil Aldin (1870–1935) began his career as a periodicals illustrator, which meant he developed, as with so many others, the ability to sketch rapidly and convey his message through line, character, and humor. He was what the British call "a sporting artist," who pictures hunting scenes, dogs, and horses. He became England's most popular portrayer of dogs, and prints of his pictures are still sold around the world. • His children's books, all concerning animals, were models of observation and vitality.

163A **The Red Puppy Book** *Henry Frowde and Hodder & Stoughton, London. 1910. Design & Illustration: Cecil Aldin* 163B **The White Kitten Book** *Hodder & Stoughton, London. 1909. Design & Illustration: Cecil Aldin* These Aldin books, cover and contents, command our attention by introducing us to lovable animals.

164A 164B

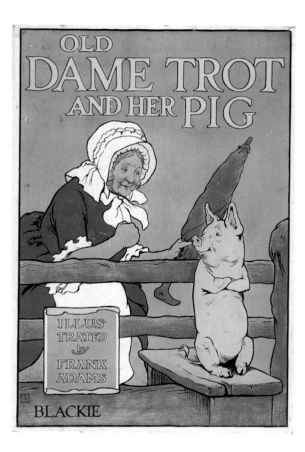

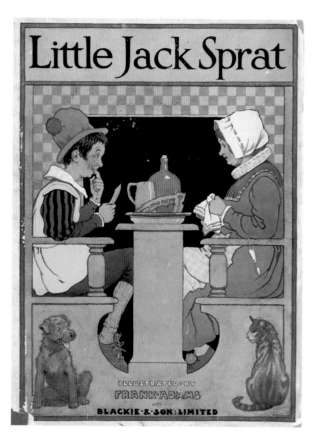

Frank Adams was a children's illustrator about whom very little is known, but his many books (published between 1903 and 1944) reveal an artist who brought each story to life with exciting draftsmanship and convincing rendering of the characters and scenes. His linear style fit well with the colors his publishers superimposed.

164A **Old Dame Trot and Her Pig** *Blackie & Son, London. c. 1910. Design & Illustration: Frank Adams* 164B **Little Jack Sprat** *Blackie & Son, London. c. 1930. Design & Illustration: Frank Adams*

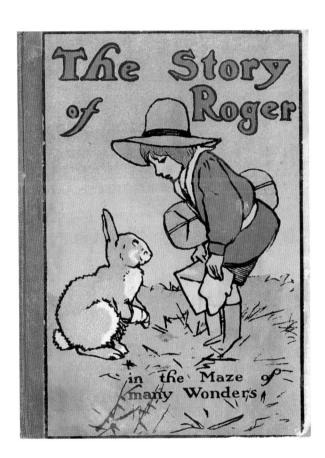

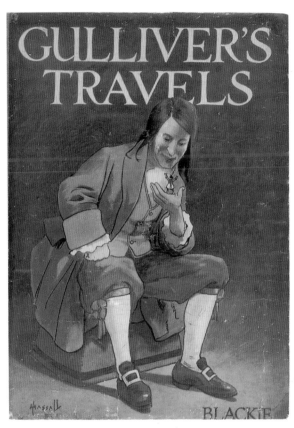

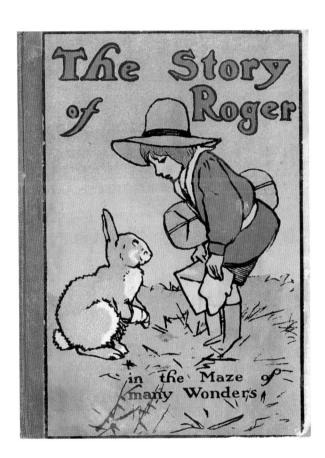 

165A 165B

John Hassall (1868–1948) studied art in Paris and Antwerp, where he became familiar with the Art Nouveau movement and *Japonisme*, the influence of which is apparent in his work. Hassall made his reputation as a cartoonist and advertising artist before he turned to illustrating children's books (about 1900). He took his profession lightly and worked with great speed. Despite these tendencies, or perhaps because of them, his work has a rare ease and boldness—a cheery bluntness.

165A **The Story of Roger in the Maze of many Wonders** *Henry Frowde and Hodder & Stoughton, London. 1900s. Design & Illustration: John Hassall* 165B **Gulliver's Travels** *Blackie & Son, London. c. 1910. Design & Illustration: John Hassall*

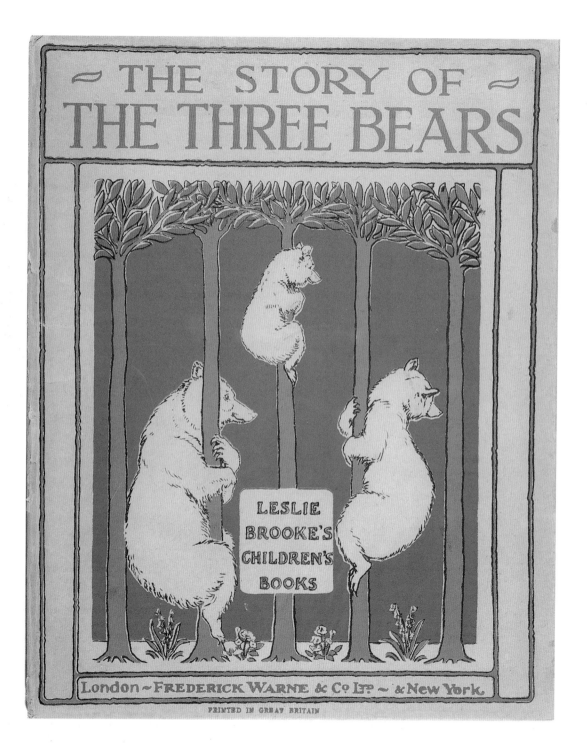

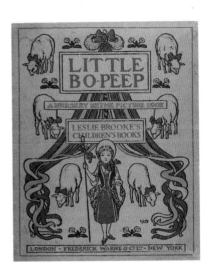 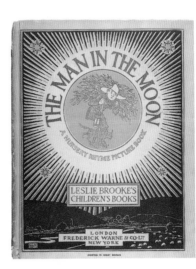 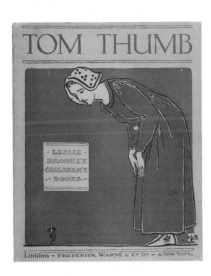

167A 167B 167C

L. Leslie Brooke (1862–1940) brought to his long career as a children's illustrator an ideal combination of talents. He was a marvelous draftsman, and all his work is based on the truth of line. He had a sunny disposition, a gentle wit, and loved both humans and animals. Further, he was happiest outdoors and in gardens, and most of his books take place in the open air. • His *Nursery Rhyme Book* (1897) is one of the first and most tireless versions of the Mother Goose rhymes, and *Johnny Crow's Garden* (1903) has been in print continuously.

166 **The Story of the Three Bears** *Frederick Warne & Co., London. 1905. Design & Illustration: Leslie Brooke* The bears here are climbing trees not because there is anything in the story to suggest this but in order to provide a pleasingly symmetrical cover design. 167A **Little Bo-Peep: A Nursery Rhyme Picture Book** *Frederick Warne & Co., London. 1922. Design & Illustration: Leslie Brooke* In this well-integrated cover, Bo-Peep has regained her sheep and looks determined to keep them. 167B **The Man in the Moon: A Nursery Rhyme Picture Book** *Frederick Warne & Co., London. 1913. Design & Illustration: Leslie Brooke* 167C **Tom Thumb** *Frederick Warne & Co., London. 1904. Design & Illustration: Leslie Brooke* The essential appeal of the story—size contrast—is forcefully presented on this cover.

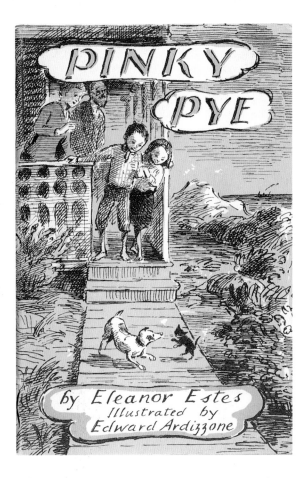

168

Edward Ardizzone (1900–1979) was a prolific illustrator of both adult and children's books who exhibited remarkable consistency, sympathy, and grace of representation. Maurice Sendak offers Ardizzone high praise, stating that Ardizzone's art "harks back to the great nineteenth-century water colorists." His covers are quietly true and convey each book's essence with few lines and simplicity.

168 **Pinky Pye** *Harcourt, Brace & Co., New York. 1958. Design & Illustration: Edward Ardizzone* 169 **Tim All Alone** *Oxford University Press, London. 1956. Design & Illustration: Edward Ardizzone*

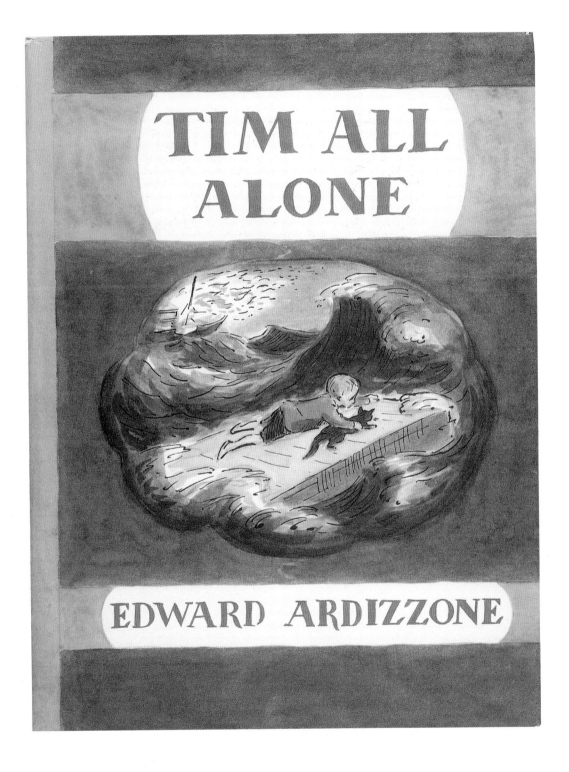

Back
covers

170 **Dolly's Adventures** *McLoughlin Bros., New York. 1880s* 171 **Baa Baa Black Sheep** *n.p., n.p. 1900s. Design & Illustration: E. Caldwell*

172

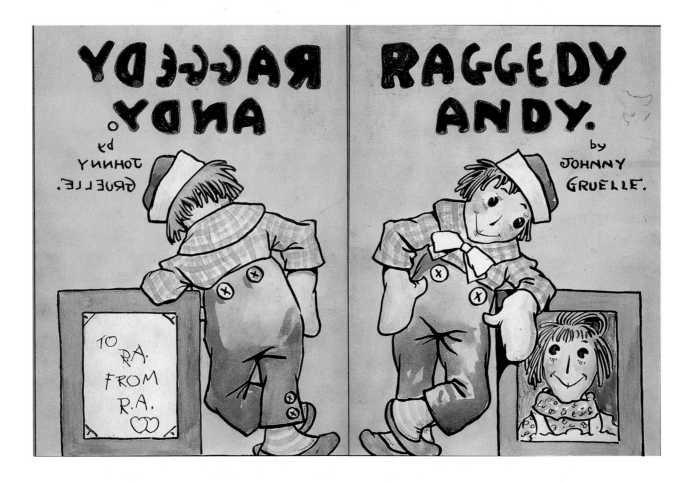

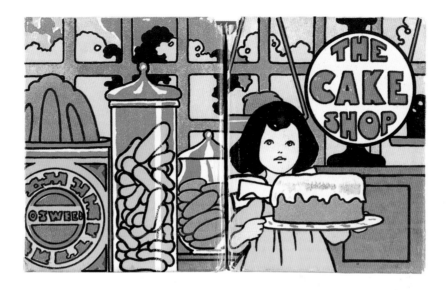

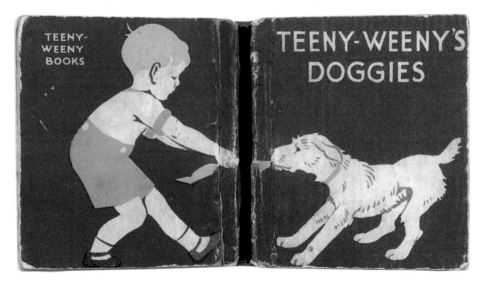

173A 173B

172 **Raggedy Andy** *Volland, Chicago. 1920. Design & Illustration: Johnny Gruelle* 173A **The Cake Shop** *Blackie & Son, London. 1907. Design & Illustration: Charles Robinson*
173B **Teeny-Weeny's Doggies** *Humphrey Milford/Oxford University Press, London. 1930s*